How Art
Can Change
Your Life

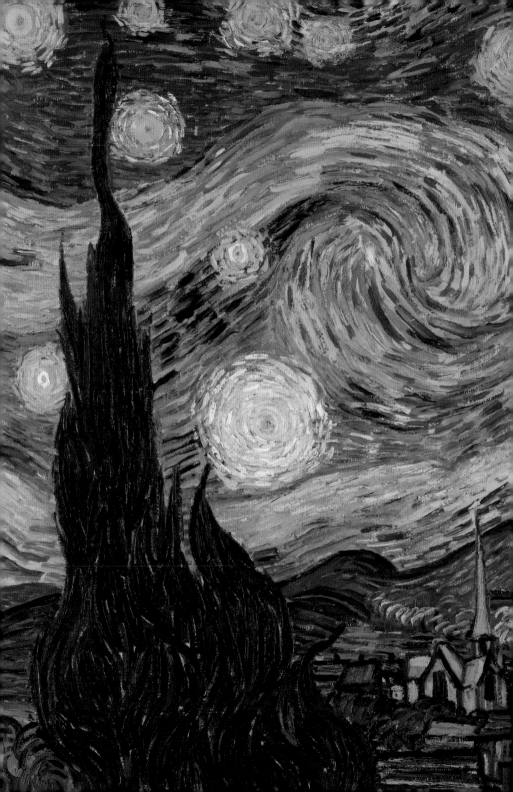

Susie Hodge

How Art
Can Change
Your Life

Contents

Introduction

Visual art can communicate with us in ways that words alone cannot. It can be enlightening, uplifting, challenging, informative, arresting and amusing. It can offer insights, share memories, suggest new ideas and work therapeutically, helping with emotional, behavioural or mental-health problems. Its effects are such that visits to museums and galleries have been prescribed by doctors for conditions including stress, burnout and loneliness, as well as to alleviate the symptoms of physical illnesses, such as dementia, in a practice known as 'social prescribing'. Every year, museums and galleries attract a wide range of visitors for a multitude of reasons, reaffirming that art is an essential part of society.

Art and emotion

Far more than just visual stimulation, art has the power to heal, to give hope, change or re-establish beliefs and attitudes, facilitate introspection and remind us of values that we may have forgotten. Reflecting society, art often shows us new perspectives, expressing realities and difficulties within our communities; it can provide fresh ideas and insights, and frequently draws attention to what may have become overlooked and invisible. From early in its history, psychology, or the science of mind and behaviour that began in the late nineteenth century, recognized art as an important means of expressing, channelling and exploring feelings, attitudes and behaviour. For centuries, artists themselves have understood the healing powers of art, and many have used it to help them cope with personal challenges. During the last couple of centuries, artists have spoken about this more. For instance, Edvard Munch wrote: 'For as long as I can remember I have suffered from a deep feeling of anxiety which I have tried to express in my art.'[1]

The Scream (detail) by Edvard Munch; see page 71.

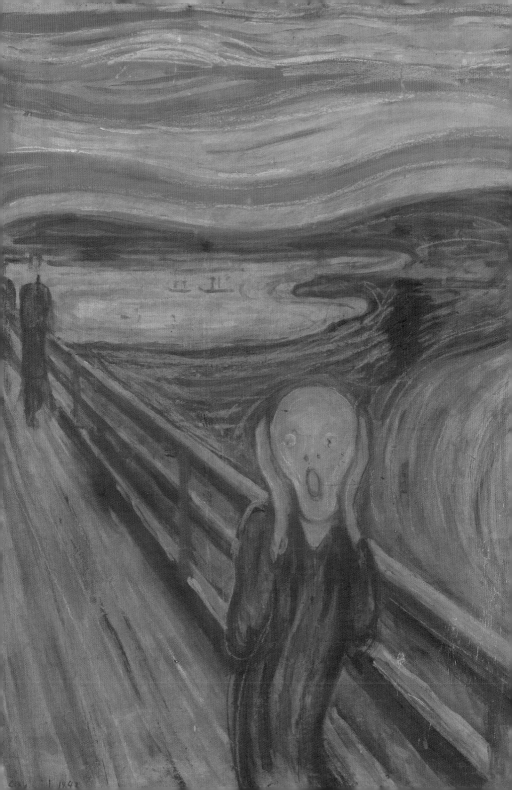

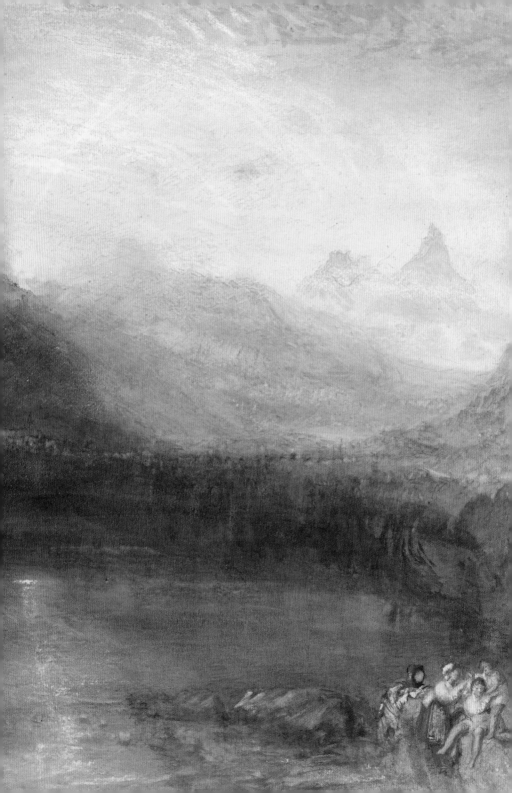

Georgia O'Keeffe mused: 'I found I could say things with colour and shapes that I couldn't say any other way; things I had no words for.'[2] Louise Nevelson explained, 'All of a sudden, I saw a crack of light.... Then I saw forms in the light. And I recognized that there was no darkness, that in the darkness, there'll always be light.'[3] And Tracey Emin has reflected, 'It's only art that has carried me through, given me faith in my own existence.'[4] It is a short step to considering that art might be used to help its viewers, too.

Powerful effects

An experiment conducted by the British neuroscientist Professor Semir Zeki, who has studied how the brain processes features such as colour and movement, revealed what happens when we look at art.[5] Scans measured the brains of individuals while they were shown paintings by artists including John Constable, Jean-Auguste-Dominic Ingres, Hieronymus Bosch, Claude Monet, Rembrandt, Leonardo da Vinci and Paul Cézanne. Professor Zeki said, 'When you look at art…there is a strong activity in that part of the brain related to pleasure.… The reaction was immediate.… The blood flow increased for a beautiful painting just as it increases when you look at somebody you love.… We didn't realize until we did these studies just how powerful an effect art has on the brain.'[6] The study found that looking at art can help to lower the body's concentration of the stress hormone cortisol, and increase levels of the pleasure hormone dopamine.

Another study, in 2016, showed that looking at images of nature, particularly landscapes and seascapes, can lower stress and thus help to prevent chronic stress and stress-related diseases. Researchers led by Vrije University Medical Centre in Amsterdam recruited forty-six participants in an experiment designed to see how looking at images containing nature could settle the nerves.[7] These are just two of many studies that prove how much art can work as therapy.

The Lake of Zug (detail) by J.M.W. Turner; see page 165.

Managing emotions

Art can help us in myriad ways. By understanding a little of an artist's intentions or processes and spending even a short time examining aspects of particular works of art, we can learn to deal better with our emotions, adopt new viewpoints and learn to approach and cope with certain situations and convictions more positively. Even unsettling art can provoke alternative ways of thinking and enable us to manage our emotions in different ways. Artists have been conveying ideas, feelings, dreams, stories, experiences, observances and aspirations for thousands of years, and this book will help you to 'read' them differently, and to reconsider and understand how to handle your own feelings. More than seventy artists and their artworks are considered, including Artemisia Gentileschi, Yinka Shonibare, Francisco de Goya, Claude Monet, Frida Kahlo, Gustav Klimt, Caravaggio, Vincent van Gogh, Elizabeth Catlett, Andy Warhol and Henri Matisse. Their work and ideas are as individual as we all are, and this is another of the many positives about using art in this way; while emotions may be universal, our interpretations and reactions are individual. Feel free to be guided by the ideas in this book, and discover how you can interact with art in many fresh and marvellous ways.

1 Ragna Stang, *Edvard Munch: The Man and the Artist* (London: Gordon Fraser, 1979).

2 Georgia O'Keeffe Museum, 'Visual Vocabulary', 6 July 2015, www.okeeffemuseum.org/visual-vocabulary.

3 Louise Nevelson, *Dawns and Dusks: Taped Conversations with Diana MacKown* (New York: Scribner, 1976).

4 Tracey Emin, *Strangeland* (London: Sceptre, 2013).

5 Semir Zeki, *Inner Vision: An Exploration of Art and the Brain* (Oxford: Oxford University Press, 2003).

6 Quoted in Robert Mendick, 'Brain Scans Reveal the Power of Art', *The Telegraph*, 8 May 2011.

7 Peter Dockrill, 'Just Looking at Photos of Nature Could Be Enough to Lower Your Work Stress Levels', *Science Alert*, 23 March 2016.

The Japanese Footbridge (detail) by Claude Monet; see page 43.

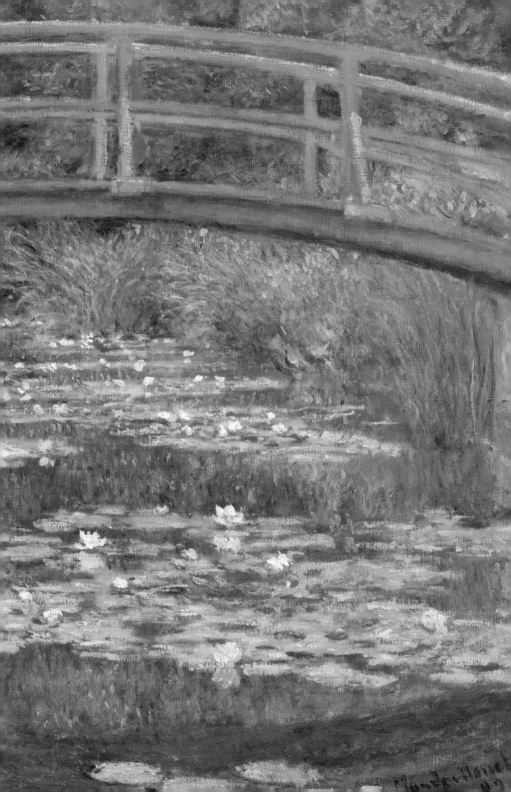

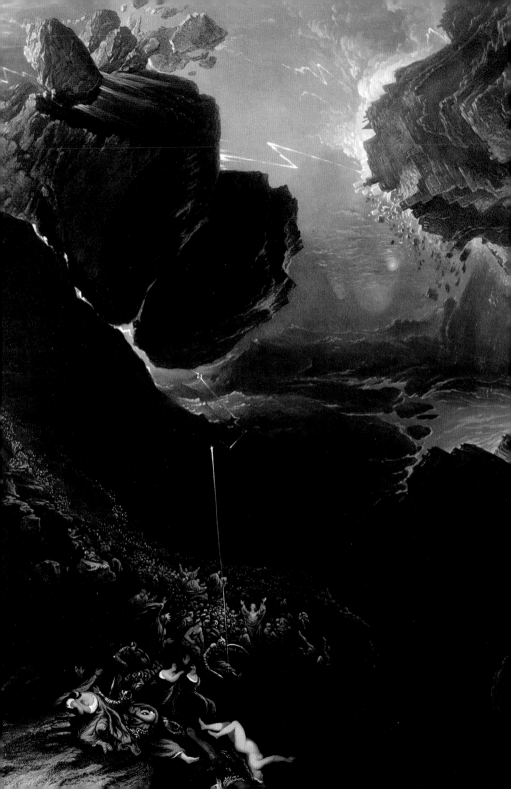

Dissipating Anger

Those who stifle, suppress or agonize over their emotions will find that those feelings fester. Such emotions end up becoming magnified to such an extent that they overwhelm or become part of those who feel them, affecting behaviour. One way of releasing or alleviating anger is through art. As a cathartic experience, creating or studying art can help us to escape from or process the everyday world. Artemisia Gentileschi, George Grosz and Francis Bacon are three examples of artists who famously used their art as an outlet for their rage. They expressed the things that angered them, and articulated how they were feeling through their subjects and the act of creation. These approaches enabled the artists to explore their emotions without harming themselves or anyone else. By addressing and channelling anger through art, energy becomes detached and dissipated, and the artist or viewer experiences a journey of self-discovery and – hopefully – acceptance.

The Great Day of His Wrath (detail)
by John Martin; see page 25.

Dissipating Anger

Giotto di Bondone *'When I see the Giotto frescos at Padua.... I perceive instantly the sentiment which radiates.'* Henri Matisse

Father of the Renaissance

Often called 'the Father of the Renaissance', Giotto di Bondone (*c.* 1267–1337) was the first artist to break away from Byzantine, Gothic and medieval styles of painting, replacing stylization with naturalism and a sense of three-dimensional space. However, despite his prominence in art history, little is known about Giotto's life, and few works have been definitively ascribed to him. Born in or near Florence, he became the most celebrated artist of his time across Italy. From *c.* 1303 he painted in the Scrovegni Chapel in Padua a fresco cycle that became internationally renowned, and in 1334 he was appointed Magnus Magister (Great Master), head architect and chief of public works of Florence. His most famous architectural design is the Campanile, known as 'Giotto's Tower'.

Three-dimensionality

One of Giotto's most famous works, this is unlike any other known paintings of the time. Drawn from observation, the figures appear solid and three-dimensional, with natural-looking faces and gestures and naturally draping clothes, conveyed through tonal contrasts. Commissioned by a Paduan moneylender, Enrico degli Scrovegni, as part of a series of frescos for the tiny chapel he had built, it illustrates a popular Bible story. Jesus is livid. With a clenched fist, he lunges at a cowering money changer. It was customary on certain holidays for Jews to make animal sacrifices and donate money to the temple, and a tradition grew for merchants to wait outside to exchange foreign currency and sell animals. In this story, Jesus loses his temper over money being changed inside the temple grounds, and drives the traders away.

Righteous anger

During the Reformation, this story was a popular subject in art, used as a symbol of the need for the Church to cleanse itself and reform. On a broader level, it shows that anger can be a powerful force for good, in the service of protecting fairness – the traders of the Bible story were cheating their often poor customers – or standing up for a strongly held belief. This image is one of purposeful anger, which can be transformative. Rather than festering and turning inwards, strong emotion such as anger or frustration can be channelled into pushing for change in one's life or in the world, becoming a source of positive energy.

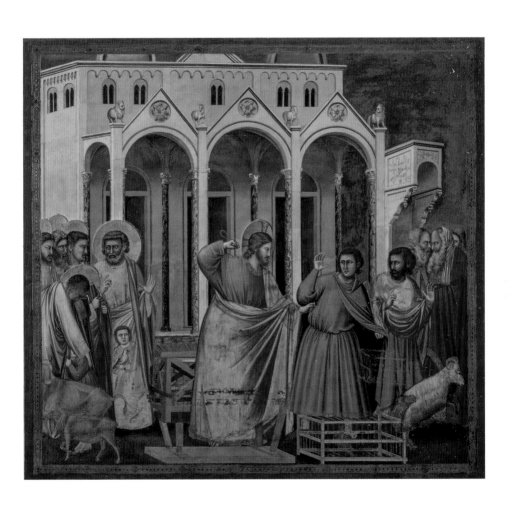

The Expulsion of the Money Changers from the Temple
1304–6 • fresco • 185 x 200 cm (72¾ x 78¾ in.) • Cappella degli Scrovegni, Padua, Italy

Dissipating Anger

Francis Bacon *'I feel ever so strongly that an artist must be nourished by his passions and his despairs.'*

Bacon's banishment

One of Britain's major figurative painters of the late twentieth century, Francis Bacon (1909–1992) was inspired by a range of artistic interests, including Surrealism, Titian, Picasso, Goya, Delacroix and Velázquez, and he became extremely influential for his paintings of tormented figures. Born to an English family in Dublin, he was named after his famous ancestor, the philosopher and scientist Sir Francis Bacon (1561–1626). He repeatedly ran away from his boarding school, and then, when he was seventeen, his father discovered that he was gay and banished him from home. He lived hand-to-mouth in London, Paris and Berlin, and in 1928 he began working as an interior designer in London. During World War II he was exempt from military service because of his asthma, and his painting career began.

Spectre-like head

In 1935 Bacon found a scientific book on various mouth diseases. It fascinated him, as he recalled: 'It had beautiful, hand-coloured plates of the diseases of the mouth…and of the examination of the inside of the mouth.' In addition, he kept several reproductions of the portrait *Pope Innocent X* (1650) by Diego Velázquez (1599–1660) in his studio, on which this painting is based. Commonly known as *The Screaming Pope*, it is a visceral, nightmarish image of human vulnerability, and emotions of fear, frustration and anger. Behind transparent curtains of paint, the figure appears to be in an electric chair. His spectral, screaming head resembles the shrieking face of a nurse shot by soldiers in the Soviet film *Battleship Potemkin* (1925), directed by Sergei Eisenstein, which Bacon admitted was a direct inspiration.

Processing raw emotion

A prolific painter, Bacon experienced intense negativity over his sexuality, especially from his own father. After his lover George Dyer died by suicide in 1971, his art became even darker. In his distorted, disturbing and unsettling paintings, Bacon explored negative feelings, including pain, fear and anger. His intense, grotesque style portrays semi-recognizable forms and distressed human figures that, as here, appear to be screaming in pain or horror, as he sought to reflect his own often raw and troubling emotions. Spending time studying images such as this can enable viewers to access and process their own difficult emotions. One might be drawn in by Bacon's vigorous, energetic paintwork to empathize with the pain and fury on display, and through this to experience some relief from the lonely intensity of these emotions.

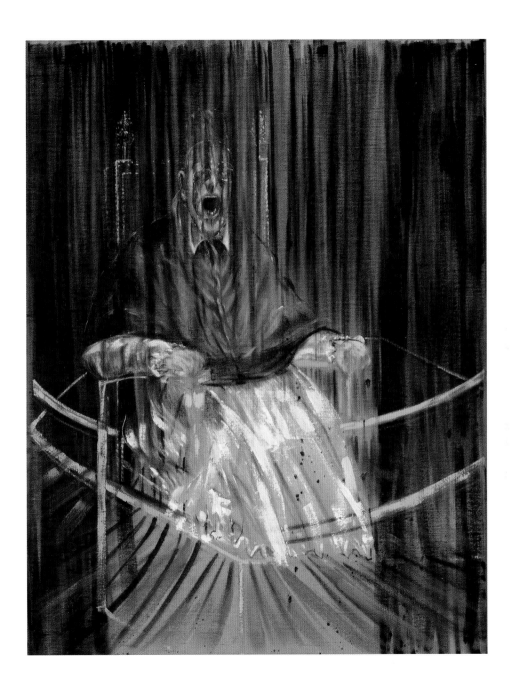

Study after Velázquez's Portrait of Pope Innocent X
1953 • oil on canvas • 153 x 118 cm (60¼ x 46¼ in.)
Des Moines Art Center, Iowa, USA

Artemisia Gentileschi *'If I were a man, I can't imagine it would have turned out this way.'*

Gentileschi's challenges

Born in Rome, Artemisia Gentileschi (1593–c. 1656) trained in the workshop of her father, Orazio Gentileschi (1563–1639), and, like him, became influenced by Caravaggio. Disregarding the restrained images expected of women artists, she painted dramatic narratives, and became widely acclaimed, the first female member of the prestigious Accademia delle Arti del Disegno in Florence. She mixed with intellectuals of the time and supported her husband and children financially. At eighteen she was raped by her father's colleague and fellow artist Agostino Tassi (c. 1580–1644). When Tassi did not marry her as he had promised, Orazio sought legal redress. During the seven-month trial, Artemisia was forced to give evidence under torture, and although Tassi was sentenced to exile from Rome, the order was never imposed.

Biblical drama

In this work, the second of two versions she made of this subject, Gentileschi portrays a scene from the Book of Judith, part of the Old Testament Apocrypha. It is the moment when Holofernes is killed by the widow Judith, who has often been described as the embodiment of female rage. The Assyrian general had invaded Judith's home city of Bethulia. By seducing him and then beheading him while he was in a drunken stupor, Judith saved her people. Gentileschi – who said, 'As long as I live, I will have control over my being' – dramatizes the moment when Judith and her maid decapitate Holofernes. His head projects from the canvas in powerful foreshortening. It is no coincidence that Gentileschi depicted herself as the heroine and Tassi as the villain.

Catharsis through creativity

Gentileschi's portraits of Tassi and herself as the protagonists in this image, and the violent intensity of the subject, seem to be a way of managing her anger, a form of artistic retribution after the suffering of her rape, the harsh and humiliating public trial and torture that followed, and the injustice when Tassi was not punished. Even if anger becomes overwhelming, there are ways to channel it and turn it into something powerful, as Gentileschi did with this image. It is clear here and in her other work that she was devoted to her craft, and may have found in it an outlet for the rage evident in the faces of both Judith and her maid. Anger may simply find its expression in creativity, a way of turning it outwards rather than suppressing it or causing actual harm.

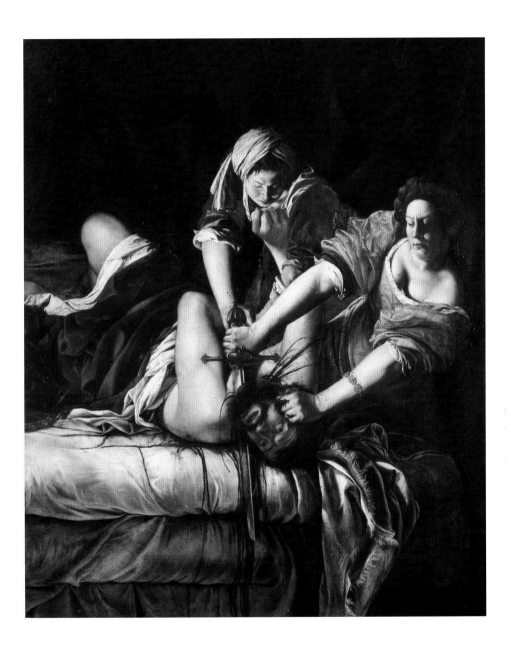

Judith Beheading Holofernes
c. 1620 • oil on canvas • 146.5 x 108 cm (57⅔ x 42½ in.)
Galleria degli Uffizi, Florence, Italy

Dissipating Anger

George Grosz *'Peace was declared, but not all of us were drunk with joy or stricken blind.'*

Grosz's disillusionment

A key artist in the Neue Sachlichkeit (New Objectivity) movement, George Grosz (1893–1959) was also involved in left-wing pacifist activity. He was born in Berlin, but moved to Stolp on the northeastern coast (now part of Poland) at the age of eight. He studied art at the Dresden Academy of Art, then in Berlin at the School of Arts and Crafts, where he mixed with the German Expressionists. At the outbreak of World War I he joined the army, but he was discharged owing to sinusitis. Recalled to the Front in 1917, he suffered a breakdown and was admitted to a military mental asylum. After the war he joined the Dada movement. His art, which the Nazis later classed as degenerate, expresses his disgust at the violence of war. In 1938 Grosz gained American citizenship.

The decay of a society

In his work, Grosz criticized what he saw as the decay of German society after World War I. This painting depicts a funeral procession in a blood-red city, dedicated to the German psychiatrist and writer Oskar Panizza, whose play *Das Liebeskonzil* (The Love Council, 1894) involves the first historically documented outbreak of syphilis and depicts God as a senile old man. Drinking from a bottle, a skeleton representing the Grim Reaper sits on the coffin; mourners are riddled with alcoholism and syphilis,

and tall buildings at precarious angles seem about to topple on to them. The work conveys Grosz's feelings of anger and distrust, as he explained, 'I painted this protest against a humanity that had gone insane.' In a letter, he described it as a 'picture of hell' and a 'gin alley of grotesque dead bodies and madmen'.

Satire, wit and ridicule

Traumatized and angered by war, Grosz railed against what he saw as a corrupt and immoral society and the governments that caused it. Through satire and allegory, he challenged the politically dishonest regime and the decadence of Germany in the 1920s and early 1930s, and his art became instrumental in awakening the general public to the reality of government oppression. The people in this painting are not specific individuals, but allegorical figures representing different classes and problems within German society at the time. Grosz is one artist of many – including William Hogarth, Banksy, Grant Wood, Raoul Hausmann, Honoré Daumier, Hannah Höch and Marcel Duchamp – who have channelled their anger into biting wit. Grosz transformed rage into laughter, using satire and ridicule as a useful way to attack and criticize the German regime.

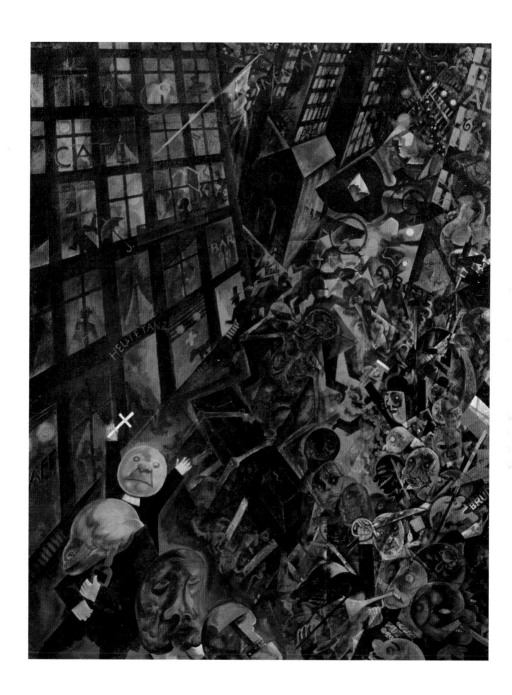

The Funeral: Dedicated to Oskar Panizza
c. 1917–18 • oil on canvas • 140 x 110 cm (55 x 43 in.)
Staatsgalerie Stuttgart, Germany

Dissipating Anger

Pipilotti Rist *'I tend to welcome all senses and the whole body of a potential spectator.'*

Rist's distortions

Known for her experimental video and installation art, Pipilotti Rist (b. 1962) creates colourful, abstract and often surreal visual and musical imagery, exploring gender, sexuality and emotion. Born in the Rhine Valley, Rist studied theoretical physics, art and film, commercial art, illustration, photography and video. She is also in a music band and designs stage sets, so music and theatricality run through her art practice. Generally lasting only a few minutes, Rist's art often incorporates familiar imagery, but with distorted elements, such as colours, speed or sound. Believing that art should encourage an open mind, destroy prejudice and create positive energy, she often investigates a range of juxtapositions, including conflicting emotions, allowing the viewer to draw their own conclusions.

Smiling destruction

The still opposite is from a slow-motion video in which a young woman in a light-blue dress and red shoes (Rist herself) smiles and strides along a street, holding a large, long-stemmed flower. The flower is actually a metal hammer, and the woman swings it, smashing the windows of parked cars as she passes them. A policewoman approaches as Rist continues to smash the car windows. As the policewoman draws near, she does not stop, but merely acknowledges the young woman with a smile

and a salute, and walks by, as if approving of the destructive behaviour. The screen is split vertically, with another video playing alongside, showing close-ups of the same flower in nature. Soft music and birdsong can be heard against the sound of smashing glass.

Encouraging complicity

This installation presents violence and the conflicting emotions of happiness and anger. Others have made destruction part of their art, such as Robert Rauschenberg (1925–2008), who erased a drawing by the revered artist Willem de Kooning (1904–1997) in 1953. In *Dropping a Han Dynasty Urn* (1995), Ai Weiwei (b. 1957) is photographed destroying a 2,000-year-old artefact. In 2018 the street artist Banksy installed an automated shredding device in the frame of his work *Girl with Balloon*. When it sold for £1 million at Sotheby's in London, onlookers watched it destroy itself. There is a fascination – even a vicarious delight – in watching someone else commit such destruction. In Rist's work, the gentleness of nature has been turned into a weapon, and rage intertwines with glee. The intimacy of the filming invites the viewer in: do we nod and smile, like the passing policewoman, or are we horrified at the violent manifestation of anger? As Rist raises her hammer, we are reminded to anger more slowly and calm our reactions.

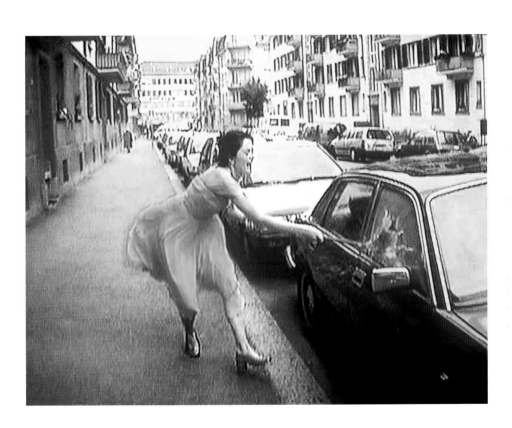

Ever Is Over All
1997 • audio video installation by Pipilotti Rist (video still) • 4:07 minutes • dimensions variable
Museum of Modern Art, New York, USA

Dissipating Anger

John Martin *'For the great day of His wrath is come, and who shall be able to stand?'* Revelation 6:17

Martin's drama

Born in Northumberland, northern England, John Martin (1789–1854) was apprenticed to a coachbuilder to learn heraldic coach-painting, and then to a painter of china. He moved to London in 1806 and began exhibiting his paintings in 1811, becoming known for his religious subjects, featuring fantastic vast landscapes, cityscapes and tiny figures. He also designed several urban improvements for London, and produced engravings of his paintings that were extremely popular; one earned him a medal in France, and Belgium appointed him Knight of the Order of Leopold. He was described as 'the most popular painter of his day', although some disagreed. His reputation ascended during the Romantic period, when huge dramatic and inspiring landscapes were especially popular.

Powerful judgment

This is the third painting in a triptych created by Martin, known as the *Judgment Series*. Inspired by an account of the Last Judgment in the New Testament, the monumental painting depicts this passage: 'And, lo, there was a great earthquake; and the sun became black as sackcloth of hair, and the moon became as blood; and the stars of heaven fell unto the earth' (Revelation 6:12–13).

While Martin adheres to the biblical description, he embellishes the image with theatrical effects, showing the cataclysmic force of nature and humans' vulnerability to God's anger. Devastation occurs everywhere: rocks and mountains move and a city is destroyed. A blood-red glow pervades the scene as lightning sends giant boulders into a chasm and figures tumble to their deaths.

Recognize and manage

Anger can become a problem if it runs out of control and causes harm. The scene in this painting is an example of anger out of control; an image of destruction, aggression and violence. Anger is a normal, healthy emotion, and is not always negative. Sometimes, feeling angry about something can help one to identify problems or damaging circumstances, can provide the motivation to create change or achieve goals, or can help in dangerous situations by giving a burst of energy. Learning healthy ways to recognize and manage anger is important for both mental and physical health. One way to manage it is just what Christian viewers would have been told in Martin's time: to be grateful. Feelings of anger can be reduced or neutralized by making a list of things to be grateful for, or focusing on what is good in life.

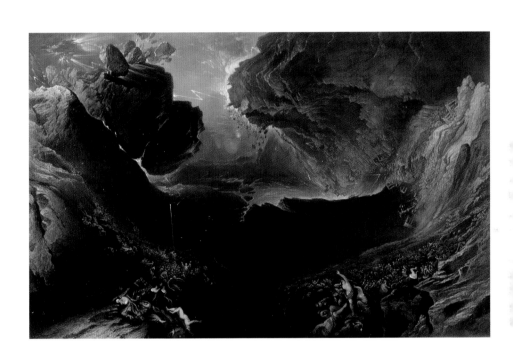

The Great Day of His Wrath
1851–53 • oil on canvas • 197 x 303 cm (78 x 119 in.) • Tate Britain, London, UK

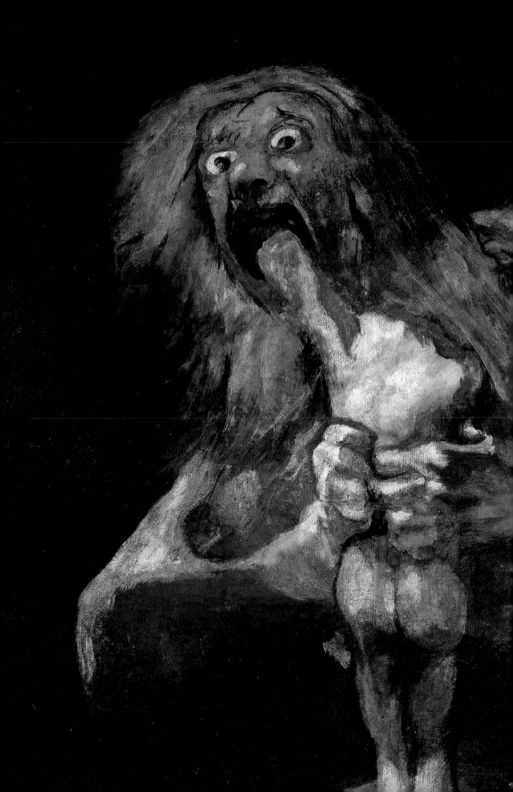

Conquering Fear

Fear is a powerful and primitive feeling involving a biochemical and an emotional response. It can arise from real threats, or from imagined dangers. Some people thrive on it, while others try to avoid situations that will cause it. It is an important human emotion that can offer protection from danger and the impetus to take action, but it can also lead to anxiety.

It was not until the late eighteenth and early nineteenth centuries that artists began expressing feelings of fear and horror through their art. This was in reaction to Neoclassicism, which was rational and logical. By contrast, Romanticism emphasized emotion and imagination. The exploration of these things in paint was first and perhaps most successfully shown by Goya and Henry Fuseli (1741–1825). Later in the twentieth century other artists, such as Käthe Kollwitz and Louise Bourgeois, produced psychological imagery that exploits universal underlying fears, while Yinka Shonibare and Winifred Knights have both exploited fears inherent in their own societies.

Saturn (detail) by Francisco de Goya; see page 39.

Käthe Kollwitz *'It is my duty to voice the sufferings of people, the sufferings that never end and are as big as mountains.'*

Anti-war

Dedicated to portraying the suffering of workers and peasants, Prussian-born Käthe Kollwitz (1867–1945) represented the fear and trauma of war. The first woman to be elected to the Prussian Academy of Arts, she grew up suffering with dysmetropsia, a neurological disorder that manifests with hallucinations and migraines. Later, at art school in Berlin, she became inspired by the work of Max Klinger (1857–1920), and from 1888, at the Women's Art School in Munich, she chose to focus on printmaking. She also produced several sculptures that continue her anti-war themes and express her empathy with human suffering. In 1914 her younger son Peter died on the battlefield in World War I, initiating her prolonged depression. Twenty-eight years later, during World War II, her grandson Peter also died in action.

Uprising

In 1893 Kollwitz attended a private showing in Berlin of Gerhart Hauptmann's play *Die Weber* (The Weavers, 1892), based on an uprising of Silesian workers in 1844, in which their employer calls in the military, and where a stray bullet kills an elderly man who had opposed the uprising. Kollwitz immediately created a series of prints called *Ein Weberaufstand* (The Rise of the Weavers) exploring themes inspired by the play, including poverty, infant mortality,

violence, rebellion and retaliation. This, the fourth of six plates in the series, conveys the perpetual struggle of the worker and the uprising when they decided enough was enough. The work received wide acclaim and was nominated for the gold medal of the Grosse Deutsche Kunstausstellung in Berlin.

Sharing

Fear is a natural and sometimes useful emotion, to which the human body reacts as though its very life is in danger. In this print, Kollwitz conveys the personal fears of the workers, but also their determination to overcome them and protest for their rights. These preoccupations were among her main areas of interest, and she and other artists, such as Dorothea Lange (1895–1965), extended this understanding of fear and feelings of isolation in their art. For instance, the photograph *Migrant Mother* (1936) by Lange conveys the trepidation and disquiet generated by the Great Depression of the 1930s. Kollwitz's image is one of collective resolve to try to improve an unjust situation. Hunger and need overwhelm each person, but when the people come together, their fear is reduced. Feelings of isolation can intensify individual fears, but the solidarity of a group helps to mitigate them.

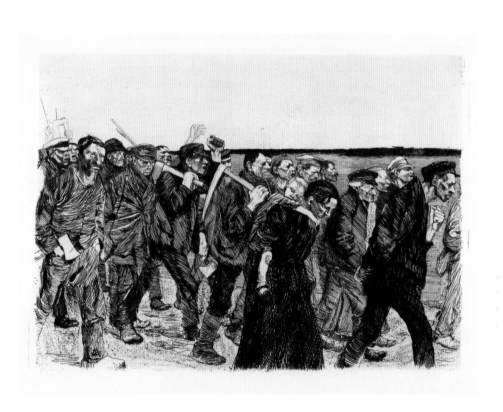

March of the Weavers
1897 • etching • 39 x 50.2 cm (15⅜ x 19¾ in.) • Private Collection

Conquering Fear

Yinka Shonibare *'It's about raising questions rather than answering them.'*

Mixing identities

Yinka Shonibare (b. 1962) was born in Britain, grew up in Lagos and returned to London at the age of seventeen. A year later he contracted transverse myelitis, a virus in the spinal column, resulting in one side of his body being paralysed, and he has used a wheelchair ever since. His art, which involves a range of media, explores such things as identity, race and class. He repeatedly uses colourful batik-printed cotton from the Netherlands that he buys in London. It was first manufactured to sell in Indonesian markets, and then was sold in West Africa. He reflects, 'The fabrics are not really authentically African the way people think…. It's the way I view culture…an artificial construct.' Shonibare has been nominated for the Turner Prize and was appointed CBE in 2019.

Corruption, greed and depravity

Without heads, these ambiguous figures in flamboyant costumes cannot be associated with any age, nationality, social class or expression, although the fabric suggests Africa and the costumes imply eighteenth-century European upper class. Based on the composition of Leonardo da Vinci's *The Last Supper* (1495–98), this work explores, among other things, corruption, greed and depravity. Shonibare said that the figures originated as a joke about the French Revolution, when aristocrats were decapitated. He created it during a banking crisis, and it comments on the growing gap between rich and poor. It explores universal human faults, including fear of societal collapse through the extravagance of some and the deprivation of others. Jesus has become Bacchus, the ancient Roman god of wine. Flanking him are the Apostles in various indecent poses.

Complicating the narrative

Shonibare once said that his greatest fear was poverty, and here the headless figures face lavish meals they could not possibly eat, intertwining suggestions of immense greed and the fear of hunger. The headless feast is both nightmarish and, as Shonibare himself has noted, surreally funny. The idea of laughing at fear is widespread, from the Bible to contemporary mindfulness practices. Humour can be used effectively to undermine or diffuse long-standing fears. Shonibare's work complicates the iconic image of *The Last Supper* – which depicts Jesus, fearing his death, and Judas, fearing what he is about to do – to pose open questions about the relationship between greed and terror, wealth and poverty, Africa and Europe. It encourages its viewers to lean into complexity, its own kind of fear, rather than seeking easy answers.

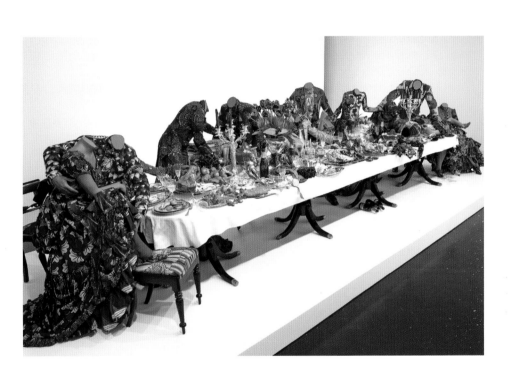

Last Supper (After Leonardo)
2013 • thirteen life-sized mannequins, Dutch wax-printed cotton, reproduction wood table and chairs, silver cutlery and vases, antique and reproduction glassware and tableware, fibreglass and resin food • 158 x 742 x 260 cm (62¼ x 292⅛ x 102½ in.) • Private Collection

Louise Bourgeois *'An artist can show things that other people are terrified of expressing.'*

Paris to New York

Famous for large-scale sculptures and installations inspired by her personal experiences, especially her father's infidelity to her mother, Louise Bourgeois (1911–2010) explored such things as the unconscious, identity, sexuality, jealousy, betrayal and fear. Born in Paris, she grew up helping in her parents' tapestry gallery and workshop. She studied mathematics, but after the early death of her mother, she began studying art instead. In 1938 she exhibited at the Salon d'Automne and married the art historian Robert Goldwater (1907–1973), with whom she moved to New York. There she joined the Art Students League, travelled to Italy, became an American citizen and began experimenting with materials. Fame came late; at the age of seventy-one, she became the first female artist to have a major retrospective at MoMA.

Ambiguous and unnerving

Bourgeois called some of her work 'cells', meaning containers of memories, enclosed rooms, cages or cells of the body. From 1989 she created several *Cells*, most constructed from a mixture of found materials, such as old doors and other objects. The cage-like structure opposite is created with iron mesh, iron bars, large panes of glass and different-sized mirrors. The mirrors create a multitude of reflections and perspectives, showing different aspects of the work's exterior and interior. Two central elements are a heavy piece of unpolished marble, which bulges in places, and a large pair of 'eyes' made from two pieces of polished black marble. These forms suggest femininity, but also voyeurism and surveillance. Overall, the sculpture appears ambiguously unnerving.

Courage and confrontation

This artwork demonstrates the connection between creativity and consciousness for both artist and viewer. Bourgeois's exploration of the unconscious here conveys the psychological manifestation of fear, exploring feelings of disquiet and entrapment. During her life she experienced fear at various times: during World War I, and of her mother's illness and her father's infidelity. Sinister and unsettling, this work stimulates underlying fear. Bourgeois commented: 'The act of looking into a mirror is really about having the courage it takes to look at yourself and really face yourself.' She set out to prove that many of our fears reflect our inner, often distorted opinions and beliefs.

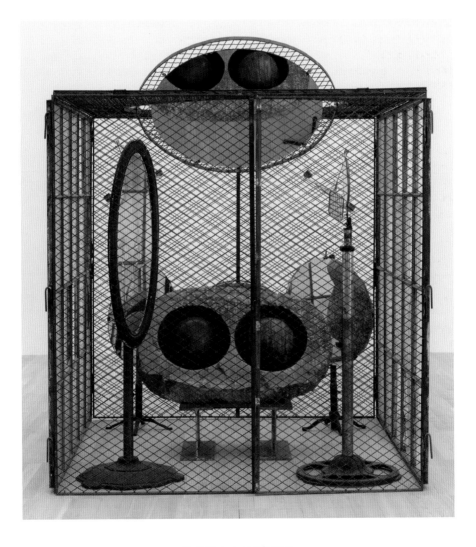

Cell (Eyes and Mirrors)
1989–93 • steel, limestone and glass • 236.2 x 210.8 x 218.4 cm (93 x 83 x 86 in.)
Tate Modern, London, UK

Conquering Fear

Winifred Knights *'I have got to this state that I can't let an aeroplane pass over my head without feeling terribly ill and shaky.'*

Women's rights

Born in Streatham, south London, Winifred Knights (1899–1947) began studying art at the Slade in London during World War I. In 1917 she was traumatized by witnessing from a tram a huge explosion at the Silvertown TNT works in east London, which killed seventy-three munitions workers and injured 400 more. Her fears were exacerbated by Zeppelin raids over London; in September 1916 more than thirty bombs fell on Streatham alone. She went to stay with cousins at their farm in Worcestershire, and there became inspired by her aunt Millicent, a campaigner for women's rights. She returned to London in 1918 and won the Slade Summer Composition Competition. In 1920 she was awarded the prestigious Scholarship in Decorative Painting by the British School at Rome for *The Deluge*. At just forty-eight, she died from a brain tumour.

Great Flood

For the Rome scholarship, students were asked to paint a scene from the Great Flood, in which, as the Bible stated, 'All in whose nostrils was the breath of life…died' (Genesis 7:22). The work, using oil or tempera, had to measure 1.8 × 1.5 m (6 × 5 ft) and be completed within eight weeks. Knights simplified her initial composition, and included people fleeing the rising waters, trying to escape to higher ground. Noah's Ark is in the distance.

Knights's mother modelled for the figure carrying a baby, and her then partner Arnold Mason modelled for two of the male figures. Knights portrayed herself as the black-skirted figure in the foreground. The background was modelled on Clapham Common.

Fear confronted

The Deluge depicts ordinary people fleeing in terror, much as Knights herself did after witnessing the Silvertown explosion, when she escaped to the country. The image can therefore be seen as a metaphor for war and other fearful experiences. It shows people frozen at different points in their escape – first raising their hands to the heavens in a plea for help, then rushing to catch up with others, glancing back at the wall of water, and finally trying to crawl upwards to safety. They are suspended between the fearful events of the present and the ominous future. Knights painted to distract herself from contemplating her fear and panic. Her paintings may trigger feelings of fear, but through the detachment of being the observer rather than the participant, they might also help the viewer to direct their feelings away from their own worries.

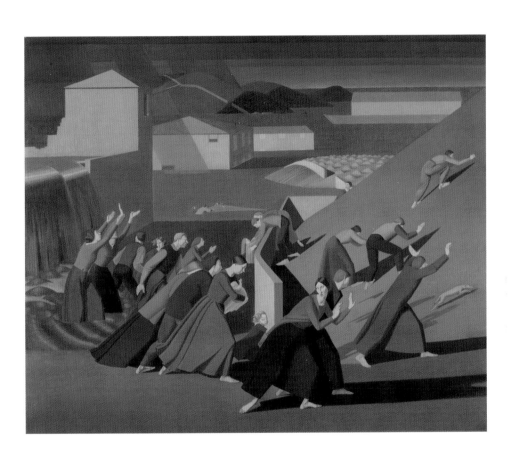

The Deluge
1920 • oil on canvas • 153 x 183 cm (60 x 72 in.) • Tate Britain, London, UK

Helene Schjerfbeck *'My portrait will have a dead expression; thus the painter reveals the soul.'*

Child prodigy

The precociously talented Helene Schjerfbeck (1862–1946) entered the Finnish Art Academy in Helsinki when she was just eleven. In 1880 she was awarded a travel grant and went to Paris, where she studied with the painter Léon Bonnat (1833–1922). In 1881 she entered the Académie Colarossi in Paris, and after receiving another scholarship, she went to Meudon and then Pont-Aven, a small fishing village in Brittany with an artists' community. She continued to move around, painting and earning money by exhibiting her work and illustrating books. During World War II, when she was dying of cancer (first diagnosed in about 1943), she moved to Sweden, and over the last two years of her life she created more than twenty self-portraits, each showing the changes the disease and ageing wrought on her appearance.

Delicate fragility

As she scrutinized her face in order to capture it, Schjerfbeck's painting style changed. Here she depicts herself as ghostly: the contours of her head dissolve and blend into shadow. Her staring, oversized left eye conveys terror, and her gaping mouth expresses fright. Only the red mark on her lower lip gives any sense of life and warmth. She was confronting death, and the lack of detail in this image communicates a raw, delicate fragility. She may have come to terms with her impending death, but in this painting she conveys fear or horror at the transience of life.

Mental toughness

During her final illness, Schjerfbeck learned to face her fears and developed the mental toughness evident here, as she displays her acceptance of the inevitable in her self-portrait. One might expect that she would have become fearful of the future, but instead of allowing this to overwhelm her, her reaction was to explore her changing appearance as calmly as she always had. This image could be regarded as an invitation for the viewer to modify their own behaviour and thoughts, to follow the artist's example. Although one may not be able to eliminate all fear, it is possible to take courage from Schjerfbeck to face it head-on, whether in creative practice or by seeking out art such as this.

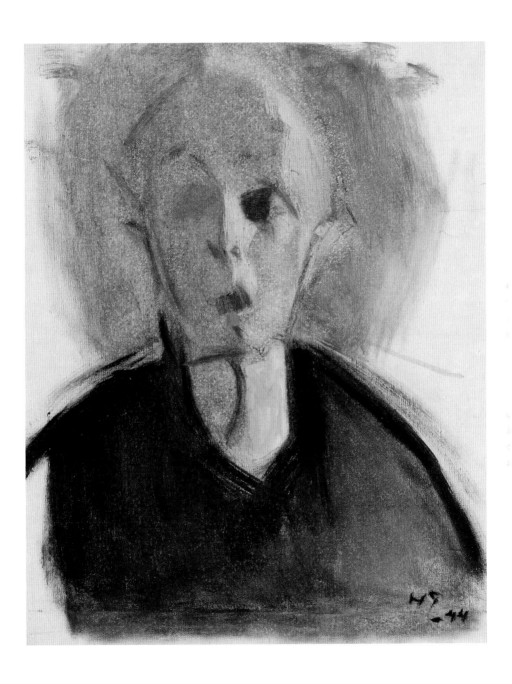

Self-portrait with Red Spot
1944 • oil on canvas • 45 x 37 cm (17¾ x 14½ in.) • Ateneum Art Museum, Helsinki, Finland

Conquering Fear

Francisco de Goya *'I have no fear of witches, goblins, ghosts or thugs.'*

Goya's emotions

Despite his modern (even subversive) ideas about social inequality, Francisco de Goya (1746–1828) became court painter to King Charles IV and was subsequently acknowledged as the leading painter and etcher in Spain. Born near Saragossa, he visited Italy in 1771, then settled in Madrid. His work was Rococo in style early on, but later more Romantic, as in his *Disasters of War* series (1810–14), which made him one of the first artists to explore his emotions through his art, rather than just the subject. In 1792, after an unexplained severe illness, he went deaf and created what came to be called his 'black' paintings on the walls of his house, reflecting his fear and anxiety for Spain and for himself. In 1824 he moved to France. A stroke left him partially paralysed, and failing eyesight made his work increasingly difficult.

Disturbing ideas

This painting depicts the Roman god Saturn eating his sons to prevent them from usurping him. It is one of the most disturbing works that Goya painted for his home, the Quinta del Sordo, along with other 'black' paintings, including a witches' sabbath and a portrait of a girl, possibly his mistress Leocadia Weiss, dressed in mourning and leaning on a tomb. Although it is not verified, Goya may have painted this when fearing his own death or insanity, and suffering from depression while the Napoleonic Wars were creating turmoil in Spain. On the other hand, it could express his fear of the world with his sudden, unexplained loss of hearing in 1819 and of losing his position as the greatest Spanish artist of the time.

Identifying what is important

This painting seems almost an image of fear itself. It shows Saturn in the process of becoming a monster through his fear, his eyes bulging and face warped, gripping his son's maimed body. Having already eaten the head and arm, he is about to take another bite. He emerges from darkness, his body dramatically lit from the side. The image illustrates the horrific potential of fear to debilitate and to arouse the darkness that might lurk beneath civilized behaviour. It shows fear out of control, pushed to its furthest conclusions; but it also, in its reflection of the artist's own fears about his deteriorating health and status, perhaps demonstrates that art might help us to explore our fears productively and identify what is important to us, which might be too difficult to put into words.

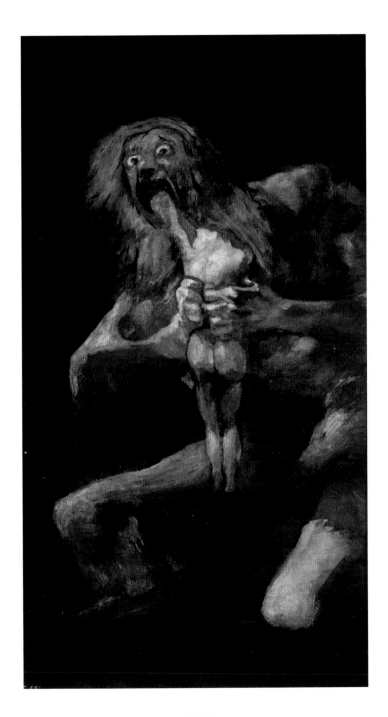

Saturn
1820–23 • mixed method on mural transferred to canvas • 143.5 x 81.4 cm (56½ x 32 in.)
Museo del Prado, Madrid, Spain

Confronting Anxiety

The American neuroscientist and author Joseph LeDoux has called anxiety 'the price we pay for an ability to imagine the future'. These feelings flourish with an active imagination, which is probably why so many artists have suffered in this way, either because of personal life events or situations, or inherently in their natural thought processes. Anxiety often means worrying about future events that might never occur, or picturing negative occurrences that could happen, such as failure, rejection, loss or disappointment. However, as some artists have discovered, art can be both liberating and therapeutic, helping to relieve or overpower this type of torment. By immersing oneself in creative processes or by exploring works of art, one focuses on the present. The artists featured in this chapter have all used art to help themselves work through their anxiety or to reflect the feelings that accompany it, or even to re-create those feelings in the viewer. Although they are certainly not the only artists to have done this, they show a wide range of approaches that have worked and that could benefit everyone.

Infinity Mirrored Room (detail) by Yayoi Kusama; see page 51.

Confronting Anxiety

Claude Monet *'Every day I discover even more beautiful things.'*

Monet's impressions

Often called 'the Father of Impressionism', Claude Monet (1840–1926) produced colourful paintings with broken brush marks that capture fleeting moments, weather effects and light. Born in Paris, he grew up in Le Havre, where as a teenager he was encouraged to paint outdoors by the landscape painter Eugène Boudin (1824–1898). In 1859 he began studying art in Paris and met other artists who later became the Impressionists. During the Franco-Prussian war of 1870–71, he stayed in London, returning in 1874 to Paris, where he exhibited in most of the Impressionist exhibitions. In 1883 he acquired a property at Giverny, northwest of Paris, where he developed a garden and a huge lily pond that became his main motif for the rest of his life.

Garden transformation

When political problems in France affected society, Monet withdrew and began painting what comforted him: the peace, beauty and calm of his garden. Gardens had always offered him a refuge from the world. In the 1870s he painted the gardens of homes he rented in Argenteuil and Vétheuil, and from 1883 his garden in Giverny became his passion. In 1893 he purchased another plot of land at the edge of the property and transformed it into a water garden. All was placed or grown to create the most harmonious views, and the water,

vegetation and muted colours created a quiet, meditative atmosphere. He painted it in different seasons and at different times of day. Inspired by Japanese *ukiyo-e* prints, he erected a Japanese bridge over his pond.

Pause and reset

Monet benefited from the therapeutic aspects of both his pond and his painting. He painted it in all weathers. From 1899 his pond became his primary motif, and this helped him through the many years of personal anxiety that followed. In the early twentieth century he began suffering with cataracts; in 1911 his wife, Alice, died, followed in 1914 by his eldest son, Jean. During World War I he refused to leave his home, even though several of his family fled. With a railway line cutting through his garden, he could hear trains carrying troops to battle, and he could also hear the guns from the Front not far away. Yet, while painting, he created a sense of peace around him, and the repetitive activity of painting the same subject over and over again must have contributed to that tranquillity. This enabled him to reset and overcome his anxiety. By studying the details of this artwork, the viewer might have a comparably calming experience.

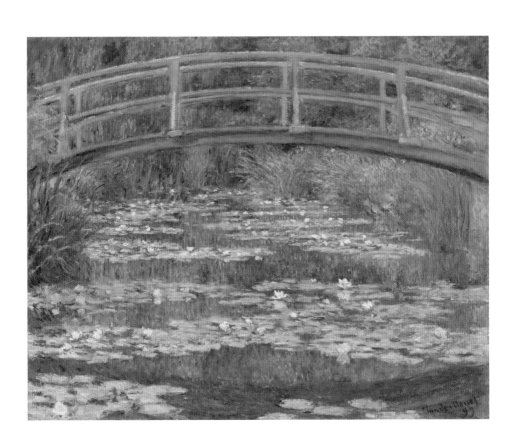

The Japanese Footbridge
1899 • oil on canvas • 81.3 x 101.6 cm (32 x 40 in.) • National Gallery of Art, Washington, DC, USA

Frida Kahlo *'Feet, what do I need them for if I have wings to fly.'*

Kahlo's suffering

Frida Kahlo (1907–1954) suffered mental and physical pain for most of her life, which may have contributed to her alcoholism. At the age of six she contracted polio, after which she walked with a permanent limp. From that time, she wore long dresses. At eighteen she was involved in a horrendous accident on her school bus. Her injuries included a punctured uterus and shattered spine, and for the rest of her life she suffered chronic pain and underwent many operations. A few years after her accident she married the artist Diego Rivera (1886–1957). It was a passionate but painful relationship. She endured miscarriages and abortions, and she and Rivera both had affairs. In 1939 he became involved with her younger sister and Kahlo divorced him. Throughout all these challenges, she painted. 'Painting', she wrote, 'completed my life.'

Symbolic self-portrait

Kahlo painted this portrait while she was divorced from Rivera (they remarried after a year). Against a background of large leaves, she faces us. A thorn necklace, held by a black monkey, cuts into her skin. A dead black hummingbird hangs from the thorns, its wings outstretched. In Mexican folk traditions, dead hummingbirds were believed to bring good luck to the wearer, so it suggests hope. The necklace and her blood recall Christ's crown of thorns. The monkey was a gift from Rivera and represents the children Kahlo had lost and longed for. She wrote: 'I am broken. But I am happy as long as I can paint.' The black cat symbolizes her depression, and the butterflies in her hair represent Christ's Resurrection – a sign that she too will rise again.

Empowerment

Having endured a dreadful illness and accident, then a tumultuous marriage, it is little wonder that Kahlo suffered from anxiety and depression. However, inspired by Rivera, she painted, examining intimate aspects of herself during some of the most difficult periods of her experience. Her paintings can be uncomfortable viewing, but in their brutal emotional honesty they reveal something of her suffering. She painted to detach herself from her physical and emotional pain, to revitalize her determination and endurance. Kahlo's art has been used by some psychologists to help women to visualize their pain and the effects of anxiety, and to talk about their own emotional and physical trauma. These doctors believe that by using art as a conduit for talking through difficult experiences, the women become re-empowered.

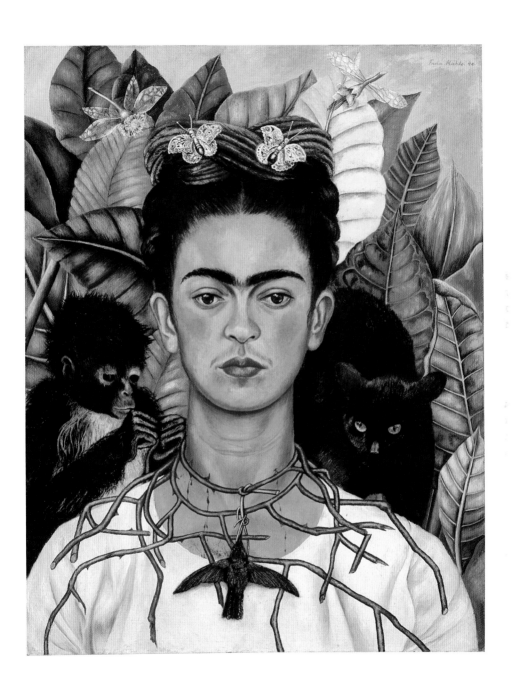

Self-portrait with Thorn Necklace and Hummingbird
1940 • oil on canvas • 61 x 47 cm (24⅛ x 18½ in.) • Harry Ransom Center, Austin, Texas, USA

Jackson Pollock *'Painting is self-discovery. Every good artist paints what he is.'*

Action man

Jackson Pollock (1912–1956) grew up in Wyoming and California. At the age of eighteen he moved to New York City and studied under the painter Thomas Hart Benton (1889–1975). He also visited museums and became inspired by, among others, Picasso, the Mexican Muralists, Joan Miró and Native American sand paintings. From 1938 until 1942 he worked for the Work Projects Administration Federal Art Project, simultaneously undergoing Jungian therapy for his alcoholism and anxiety. Later he expressed some Jungian concepts in his paintings. In 1947 he began working on huge canvases on the floor, breaking with traditional easel painting and developing what became called 'action painting'. By 1956 his relationship with his wife, the artist Lee Krasner (1908–1984), had broken down, and that year he died in a car crash.

Psychic automatism

In 1945 Pollock and Krasner moved to East Hampton on Long Island, where he began painting his huge abstract works. This one was created with his canvas laid on the floor. Using house paint, he worked with the Surrealists' method of 'psychic automatism', allowing his unconscious mind to take control as he worked in an almost ritualistic manner. With sticks and knives as well as brushes, he poured, dripped, splattered and flicked paint on to the canvas from all sides, creating patterns and skeins of colour and texture with thick and thin rhythmic lines. In this way he emphasized the physical act of painting as an essential part of the finished work. He 'signed' the painting in the upper corners with his handprints.

Jungian psychology

The emotionally volatile Pollock vented his struggles in drinking binges that usually ended in violence. From 1939 to 1940, he was a patient of a Jungian psychologist. Carl Jung (1875–1961) separated the persona, or the self-image presented to the world, from the shadow, the unknown, instinctive and irrational side of the personality that often contains hidden anxiety. He also believed in the personal unconscious, which contains individual memories and ideas, and a collective unconscious, which holds memories and ideas shared by everyone. Jung believed that by accessing these things, we can bring repressed thoughts to the fore and discover the source of anxiety as well as the strategy needed to heal it. That was why Pollock used automatism in his painting. If we similarly 'lose' our conscious selves in a work of art, we might find that unconscious elements surface, allowing access to underlying meanings and moving towards healing our own anxiety.

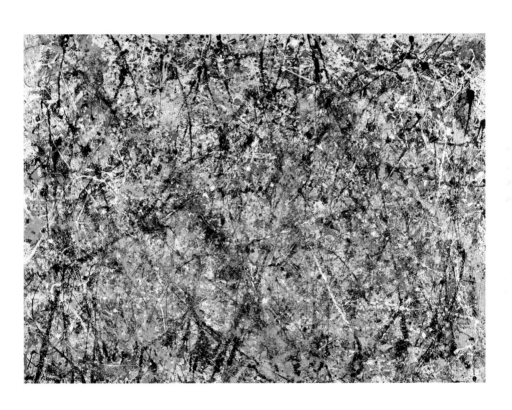

Number 1, 1950 (Lavender Mist)

1950 • oil, enamel and aluminium on canvas • 221 x 299.7 cm (87 x 118 in.)
National Gallery of Art, Washington, DC, USA

Gustav Klimt *'Whoever wants to know something about me, they should look attentively at my pictures and there seek to recognize what I am.'*

Love of beauty

The Viennese artist Gustav Klimt (1862–1918) initially painted large works in public buildings, but he developed a more ornamental, sensuous style, amalgamating elements of Symbolism with the flowing contours of Art Nouveau and his own sense of beauty. After studying at the Kunstgewerbeschule (School of Arts and Crafts) in Vienna, he painted realistic images, but he soon broke with the official artists' association and became one of the founders of the Vienna Secession, a group of artists and architects who worked in various styles, organized their own exhibitions and produced their own progressive journal, *Ver Sacrum* (Sacred Spring). From 1898 Klimt worked in a style that became known as his Golden period, when, reflecting his interest in Byzantine mosaics, he gilded his paintings with gold leaf.

Italian light

In 1913 Klimt broke with his habit of spending three months at Attersee Spa in the Austrian Alps, and instead visited Lake Garda in Italy. The change of country and, indeed, the entire visit made a deep impression on him. He painted this view from a boat out on the water, and captured the clear light and life of the place. Using the square format he preferred for his landscapes, he filled the composition with the lake, buildings and vegetation. Only a sliver of sky is visible in a top corner, while just over one fifth of the canvas features the calm water of the lake. Intended to be uplifting, the image is filled with light, soft colours and angled shapes over the shimmering water.

Tip of the iceberg

Although the Austrian establishment was conservative, some original thinkers came to the fore. Among them was 'the Father of Psychoanalysis', Sigmund Freud (1856–1939), who developed the notion of 'ideational mimetics', which explained how works of art could create an exchange of energy – both physical and mental – with viewers. He maintained that art initiates feelings akin to empathy, and that the human mind is structured into two main parts: the conscious and the unconscious. He compared this to an iceberg; the tip that is visible above water represents the conscious mind, while the huge expanse of ice beneath the water represents the unconscious mind. Freud inspired Klimt to create art that sought to reach into viewers' conscious and unconscious minds. This absorbing composition encourages the viewer to visualize themselves in this place, its soft tones and shimmering water inspiring calm and creating space for the inner reflection that can often soothe anxiety.

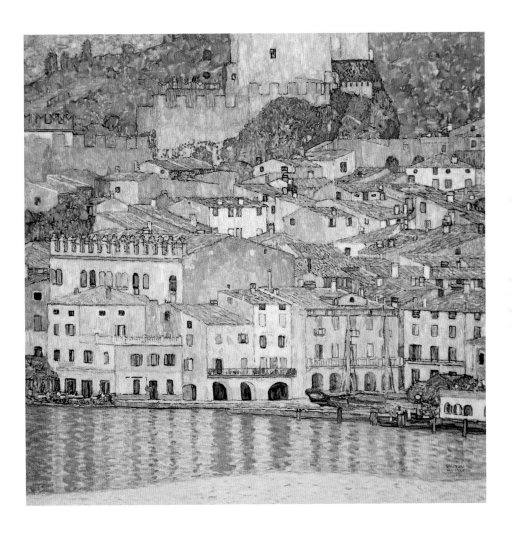

Malcesine on Lake Garda

1913 • oil on canvas • 110 x 110 cm (43⅓ x 43⅓ in.)
destroyed by fire in Schloss Immendorf, Austria, 1945

Confronting Anxiety

Yayoi Kusama *'I fight pain, anxiety and fear every day, and the only method I have found that relieves my illness is to keep creating art.'*

Yayoi's visions

Born in 1929 in Matsumoto, Japan, Yayoi Kusama came to international attention in 1960s' New York for her extensive creative practice that has encompassed installation, painting, sculpture, fashion design and writing. When she first experienced visual and aural hallucinations at the age of around ten, she began painting. She studied the traditional Japanese style of *nihonga* painting in Kyoto before moving to New York City in 1958, and there she mixed with artists including Andy Warhol (1928–1987). She came to public attention with a series of 'happenings' in which naked participants were painted with brightly coloured polka dots, and since returning to Japan in 1973, she has become known particularly for installations that intentionally disorientate the viewer with mirrors and light effects.

Infinity and beyond

Kusama investigates the idea of infinity, and in the subdued light of this installation, it is unclear where the space begins or ends, which creates a form of hallucination for the viewer. Kusama planned the construction of the space carefully, placing the mirrors and lights strategically to create disorientating illusions. Visitors enter on a mirrored walkway. The walls and ceiling of the room are also mirrored, and the floor surrounding the walkway is covered with a shallow pool

of water. Hanging from the ceiling are hundreds of small LEDs that flash on and off in different colours on a timed programme. These pinpricks of light in the darkened room are reflected in the mirrors and the water.

Changing perception

Kusama has stressed the importance she places on the viewer's individual experience in her installations. Throughout her career, she has been fascinated with ideas of perpetuity, following on from her childhood, when she suffered anxiety and hallucinatory episodes, often in the form of nets or spots that multiplied in her mind's eye. These hallucinations became the basis of much of her art, and *Infinity Mirrored Room* exemplifies her examination of repetition and endlessness. Art, especially immersive, interactive art such as this, also changes a person's perception of their own world, which was what Kusama was aiming for when creating her 'infinity rooms'. Having experienced therapy throughout her life, she has a particular understanding of how to transform viewers' outlooks and experiences through her art. Once each viewer is immersed in the work, their attitudes and emotional states alter, and the effect is often one of tranquillity and positivity.

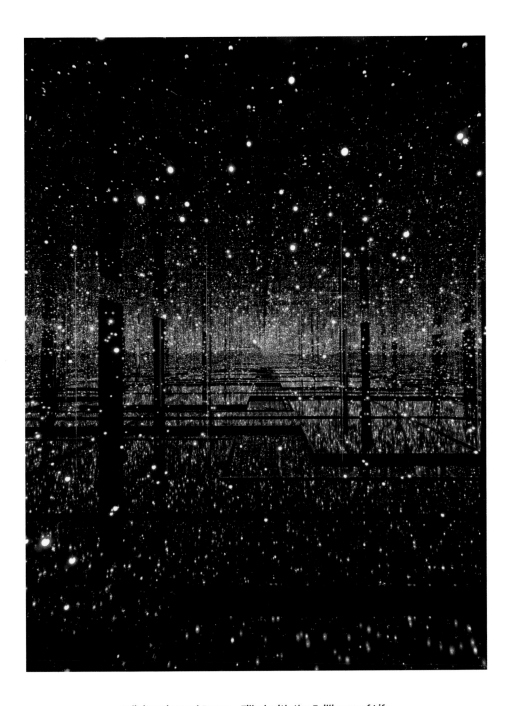

Infinity Mirrored Room – Filled with the Brilliance of Life
2011/2017 • mirrored glass, wood, aluminium, plastic, ceramic and LEDs
295.5 x 622.4 x 622.4 cm (116⅓ x 245⅛ x 245⅛ in.) • Tate Modern, London, UK

Camille Claudel *'There is always something missing that torments me.'*

Claudel's ordeals

Known now for her emotive and lifelike sculptures of figures in bronze and marble, the French artist Camille Claudel (1864–1943) began sculpting with clay at twelve years old. When the sculptor Alfred Boucher (1850–1934) saw her work, he recommended that she train at the Académie Colarossi, where – uncommonly – female artists were welcomed and allowed to draw from the male nude. Claudel also shared a studio with three other female sculptors, and Boucher regularly advised on their work. After he moved to Italy in 1883, his role was taken by Auguste Rodin, and soon Claudel became Rodin's assistant, muse and lover. However, when he refused to end his long-term relationship with Rose Beuret, Claudel ended the affair. Her mental health suffered and her family had her admitted to an asylum.

Roman mythology

Between 1886 and 1888 Claudel produced two terracotta versions of this sculpture and another in plaster. These were known as *Sakuntala*, after a story from the *Mahabharata* about a reunion between a wife and husband, Sakuntala and Dushyanta, after a long separation. The plaster version won an award at the Salon des Artistes Français in 1888. Almost twenty years later Claudel was commissioned to produce a slightly smaller, marble version, renamed *Vertumnus and Pomona* after an ancient Roman myth in which Pomona, a beautiful wood nymph, rejects the attentions of Vertumnus, but finally falls in love with him. Claudel's emotional portrayal of the male and female nude shows love as a power of the mind as well as a physical attraction, with the lovers both vulnerable and equal.

Resilience and determination

Rodin and Claudel were lovers for almost a decade: 'My Camille, be assured that I feel love for no other woman, and that my soul belongs to you,' wrote Rodin in 1886. Claudel's family rejected her over the affair, and she became financially dependent on Rodin. Yet she bravely cut ties with him – and her whole life fell apart. Despite his recommendations, she struggled to find work. Her art was deemed too similar to his, and too sexual for a woman. She developed paranoia, and began destroying her work. Anxiety can be overpowering, generating feelings of loss and disconnection, and Claudel experienced it all. Originally called *L'Abandon* (*The Abandonment*), this sculpture depicts two lovers reuniting. Betrayed by her lover and her family, Claudel accomplished the work through her own resilience and determination. She brought her personal experiences to bear on the story of Sakuntala, as viewers might bring their own anxiety to their study of her sculpture.

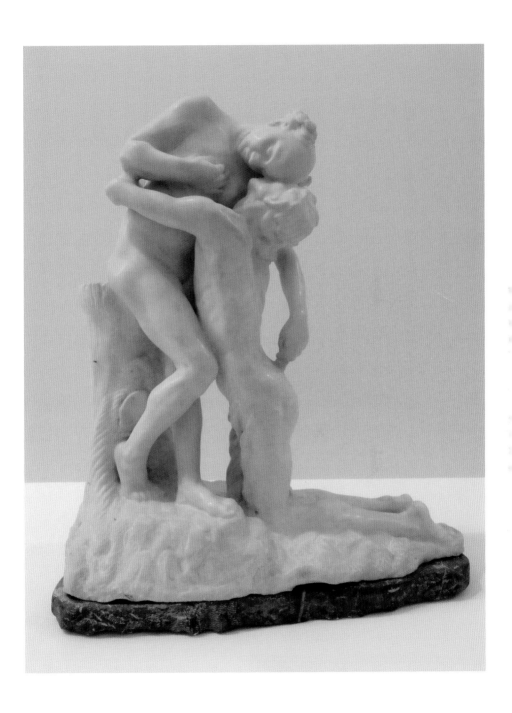

Sakuntala (or Vertumnus and Pomona)
1905 • marble • 91 x 80.6 x 41.8 cm (35⅞ x 31¾ x 16½ in.) • Musée Rodin, Paris, France

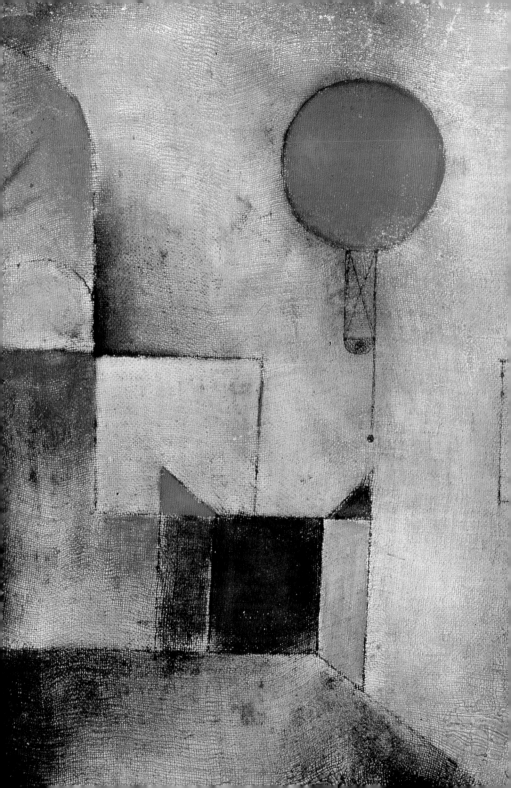

Relieving Stress

Stress is something that influences daily life. It affects everyone differently, and every person deals with it in a different way. When Picasso observed that 'art washes away from the soul the dust of everyday life', he was showing his understanding of the fact that art can be a stress-buster.

Research has found that the act of enjoying or creating art has powerful healing properties for both mind and body, and so can lessen stress. Somewhere between exercise that works the body, and meditation that clears the mind, art promotes healing by compelling the viewer to connect with their thoughts and surroundings, which, rather like a form of mysticism, can reset their outlook. Many artists, including Agnes Martin, Jean-Michel Basquiat, Paul Klee, Georgia O'Keeffe and Joan Miró, have relieved their own stress and helped to ease that of their viewers using various methods and artistic approaches. This chapter explores ways in which they have done so and, specifically, how everyone can use art as a tool for coping with stress.

Red Balloon (detail) by Paul Klee; see page 65.

Relieving Stress

Georgia O'Keeffe *'I've been absolutely terrified every moment of my life – and I've never let it keep me from doing a single thing I wanted to do.'*

American modernism

Regarded as a pioneer of American modernism and Feminist art, Georgia O'Keeffe (1887–1986) produced more than 2,000 works of art. She was born in Wisconsin, studied at the Art Students League, joined the political National Woman's Party supporting women's suffrage, and became the first woman to have a retrospective at the Museum of Modern Art in New York. Her drawings first caught the attention of the photographer and New York gallery owner Alfred Stieglitz (1864–1946), who became her chief promoter and then her husband. From the early 1920s she produced large-scale paintings of flowers and skyscrapers. In 1929 she first visited New Mexico, and twenty years later she moved there permanently, painting the landscapes, skies and natural forms around her. She received many accolades, and despite failing eyesight in later life, continued producing art.

Organic shapes

Amalgamating representation and abstraction, this painting is based on the organic shapes and colours of a flower. While many observers, including O'Keeffe's husband, suggested that these abstracted images represent elements of the female anatomy, O'Keeffe always denied it. She said, 'I made you take time to look at what I saw and when you took time to really notice my flower, you hung all your associations…

on my flower and you write about my flower as if I think and see what you think and see, and I don't.' Combining hard and soft lines, curves, tonal gradation and vibrant colour with a sense of tension through the cropping at the edges, the image has a powerful impact. The oversized details are both unexpected and, some would say, ambiguous.

Colour and mood

Through her understanding of the psychological and emotional impact of colour, O'Keeffe creates a sense of calm here. Before painting, she painstakingly considered her palette and colour placement. She created 'colour cards', a variety of colours blended together on small paperboard rectangles that she cut out and arranged in order to see different effects. She wrote that colour was 'one of the great things in the world that makes life worth living'. Studying colours or making colour cards can be surprisingly helpful in calming stressful thoughts, creating 'space' in the mind.

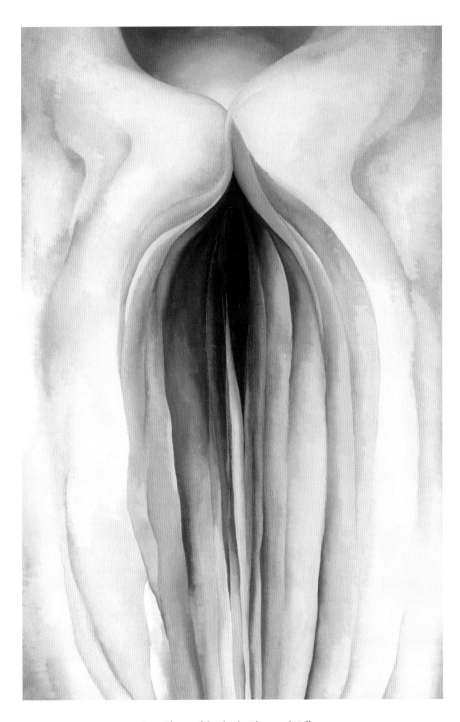

Grey Lines with Black, Blue and Yellow
1923 • oil on canvas • 121.9 x 76.2 cm (48 x 30 in.) • Museum of Fine Arts, Houston, Texas, USA

Relieving Stress

Jean-Michel Basquiat *'I don't think about art when I'm working. I think about life.'*

X-ray-style figures

Known for his gestural style of painting, Jean-Michel Basquiat (1960–1988) first painted as part of a graffiti duo called SAMO© – short for 'Same Old Shit' – in Lower Manhattan during the late 1970s. Of Haitian and Puerto Rican heritage, Brooklyn-born Basquiat became famous after exhibiting in the Times Square Show in 1980 along with several established artists. His paintings express his origins in graffiti, blended with references from high and popular culture, and elements from African, Caribbean, Aztec and Hispanic art. Using a range of materials, including oil and acrylic paints, watercolours, charcoal, coloured pens and oil pastels, he produced X-ray-style figures and energetic marks.

Raw energy

Dominated by a dark, frantic-looking figure emerging from a gold and grey background that suggests an urban location, this painting conveys raw energy. The figure, with bloodshot eyes and spiky hair, is surrounded by lines, scribbles and geometric shapes. He holds up his hands, but it is not clear what is happening. Is he in a violent rage? Is he defending himself or attacking? Is that a halo above his head? Is he a saint, or a warrior, victim or martyr? The painting is intentionally equivocal, while also conveying Basquiat's idea of how he was perceived. He painted it soon after he had become internationally recognized, when he was extremely conscious of his identity as one of few Black artists to achieve celebrity status.

Distraction

One of the first graffiti artists to penetrate the official art world, Basquiat often painted imagery to convey commonly held views of his Black identity. His scribbled style fuses elements of autobiography, social comment and graffiti. The widespread racism he experienced as a Black American affected his work deeply. Mocking racist depictions of Blackness, Basquiat here depicts his figure in a self-consciously 'primitive' style, projecting his underlying resentment of such tropes. When painting vigorously, his mind was distracted, 'in the flow' of creating the work, almost in a state of meditation. This is a common phenomenon and one of the simplest psychological techniques for rapid stress relief: do something so deeply absorbing that it distracts you from whatever is affecting you. Try making vigorous marks, using any materials and working rapidly. Don't worry about the outcome, simply replace your negative thoughts with action.

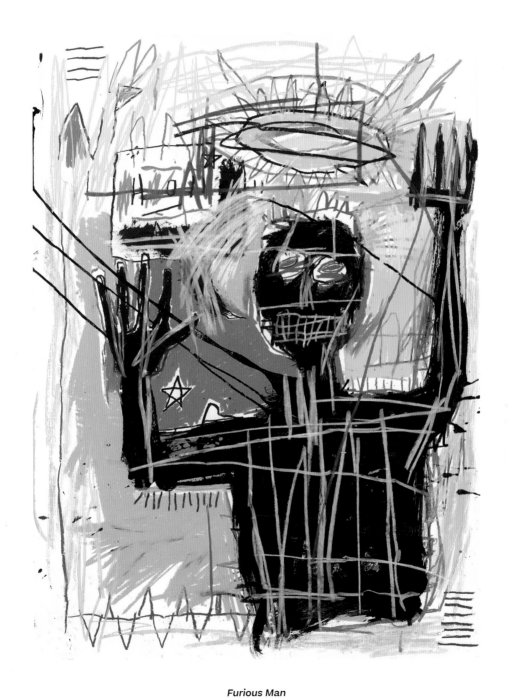

Furious Man

1982 • oilstick, acrylic, wax crayon and ink on paper • 76.2 x 55.8 cm (30 x 22 in.)
Private Collection

Andrew Wyeth *'I dream a lot. I do more painting when I'm not painting. It's in the subconscious.'*

Emotionally charged

The youngest of five children, Andrew Wyeth (1917–2009) learned art from his father, the successful illustrator N. C. Wyeth (1882–1945). The family lived in both Pennsylvania and Maine, areas that feature often in Andrew's work. Home-tutored because of delicate health, he studied art history, music and poetry, and learned to paint in watercolour and tempera, which were very different from traditional oil paint. His father nurtured all his children's talents, and the family was a close one. Wyeth's siblings were all capable and successful, becoming artists, an inventor and a musician. Tragedy struck, however, in 1945. Wyeth's father and his three-year-old nephew were killed when their car stalled on railway tracks and was struck by a train. From that time, Wyeth's art became especially haunting and emotionally charged.

Resolute and determined

A young woman sits in a field, looking towards a house with outbuildings. Tawny grass suggests that there has been no rain. Wyeth had a summer home near Cushing in Maine, and the woman depicted here is his neighbour Christina Olson. Suffering from a degenerative muscle condition, she could not walk, but, rather than use a wheelchair, she pulled herself about by her arms. Wyeth had been inspired to create the painting when he saw Christina resolutely dragging herself across the field. She was fifty-five, and he blended aspects of her with his wife, Betsy, who was then in her mid-twenties. Betsy suggested the painting's title, which indicates that it is a portrayal more of a state of mind than of a place.

Transcendentalism

Wyeth wrote that Olson was 'limited physically, but by no means spiritually', and that 'the challenge was to do justice to her extraordinary conquest of a life which most people would consider hopeless.' She seems vulnerable and isolated, but the image expresses far more than that. It encompasses anyone who has faced and beaten adversity.

Wyeth was also inspired by his father's admiration for the philosopher, poet and transcendentalist Henry David Thoreau (1817–1862). Transcendentalists believe in the power of self-reliance and in being true to oneself. Among Thoreau's personal interests were notions of personal endurance and happiness in the face of stressful situations, qualities that can be encouraged through self-belief. This painting shows how Wyeth followed these concepts, conveying to the viewer that almost anything might be overcome through self-belief and determination.

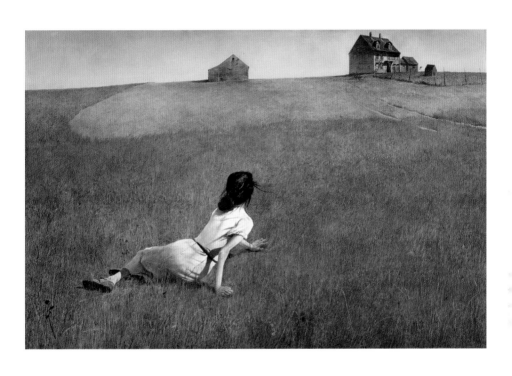

Christina's World
1948 • tempera on panel • 81.9 x 121.3 cm (32¼ x 47¾ in.)
Museum of Modern Art, New York, USA

Relieving Stress

Agnes Martin *'Art is the concrete representation of our most subtle feelings.'*

Eastern philosophies

Agnes Martin (1912–2004) grew up on a farm in Vancouver and moved to Washington State in 1931. She studied there and later in New York, where she encountered work by artists including Arshile Gorky (1904–1948), Adolph Gottlieb (1903–1974) and Joan Miró. In 1947, at the University of New Mexico in Taos, she took lectures with a Zen Buddhist scholar and became fascinated by Asian philosophies. Martin spent eighteen months camping across Canada and the United States, then settled in New Mexico in an adobe home she built herself. Her abstract paintings are associated mainly with New Mexico, her early life on a Canadian farm, and Taoism and Buddhism. She has been described as a 'closeted homosexual', and suffered with paranoid schizophrenia.

The idea of absence

In the early 1960s Martin began painting huge canvases covered in fields of subtle colour and faint, meticulously drawn grids. They were described by curators as Minimalist, but she associated herself with Abstract Expressionism, and they displayed her interest in Eastern ethics. *Night Sea* is an example of her process that she described as coming from 'elsewhere, at a safe remove from the art'. 'Elsewhere' to Martin were places where she felt safe and calm. The influence of Asian philosophies can be seen in her presentation of the idea of 'absence' and her encouragement of the viewer to look below the surface. The work conjures notions of looking into a deep ocean at night; the fine, threadlike network of gold emphasizes the blue.

Uplifting responses

Martin experienced a great deal of stress during her life, particularly through her schizophrenia, which manifested with auditory hallucinations, depression and trances, and for a period she was frequently hospitalized. Stress can have a huge impact on both mental and physical health. Whether one resolves feelings of stress or has to live with them, it is important to try to replace those thoughts with calm, positive ones, and with *Night Sea*, Martin aimed to encourage this. She insisted that her paintings did not reflect personal emotions or biographical elements, but that they would stimulate uplifting responses, creating an upbeat, relaxed mindset and helping to relieve stress in all her viewers.

Night Sea
1963 • crayon, gold leaf and oil on linen • 182.9 x 182.9 cm (72 x 72 in.)
San Francisco Museum of Modern Art, California, USA

Paul Klee *'I paint in order not to cry.'*

Colour and music

A Swiss-born German artist, Paul Klee (1879–1940) chose between art and music as a teenager, and continued to play the violin throughout his life. Inspired by Cubism, Expressionism and Surrealism, as well as colour theory, he wrote and lectured on art and taught at the Bauhaus school and the Düsseldorf Academy. His work reflects his sense of humour, beliefs and musicality. Although he studied art, the techniques of painting and colour initially eluded him. He spent time in Italy, experimented with creative approaches and became part of the Expressionist groups Der Blaue Reiter and Die Blaue Vier. In 1914 he visited Tunisia, where the light changed his entire outlook. He wrote, 'Colour has taken possession of me. No longer do I have to chase after it.' Soon afterwards, he began painting.

Leading the eye

In the work shown here, demonstrating Klee's recently discovered proficiency at painting, colours and angled lines are placed to lead the eye towards the red circle in the centre of the canvas. It could be the balloon of the title, or a sun. The geometric shapes around it appear weightless but suggest a cityscape. They also convey Klee's admiration of children's drawings and other artistic ideas developing in Europe at the time, including Neo-Plasticism, Suprematism and Constructivism, even though Klee never wanted to be artistically categorized, which is why he kept changing his content, technique and style. Although this is an abstract composition, the painting has a representational title, leading viewers to find aspects of life in it. However, the depiction is more expressive than descriptive.

Post-traumatic growth

In 1931, a Nazi newspaper described Klee's art as degenerate. His home was ransacked by the Gestapo, he was fired from Düsseldorf Academy and many of his paintings were seized. In 1933 he began suffering with a painful illness, yet he managed to produce more than 1,000 works during his final years, many dealing with his personal stress. Like Andrew Wyeth, Klee was a Transcendentalist, and one aspect of transcendental belief is that the material world is only one of several realities, and that creativity comes from beyond consciousness. Klee used the process of making art as meditation, saying that it helped him to live in an 'intermediate world'. A phenomenon known as 'Post-Traumatic Growth' is where people who have suffered extreme stress use the experience to enhance and appreciate life and also learn to embrace new opportunities, cultivating inner strength through the knowledge that they have overcome tremendous hardship.

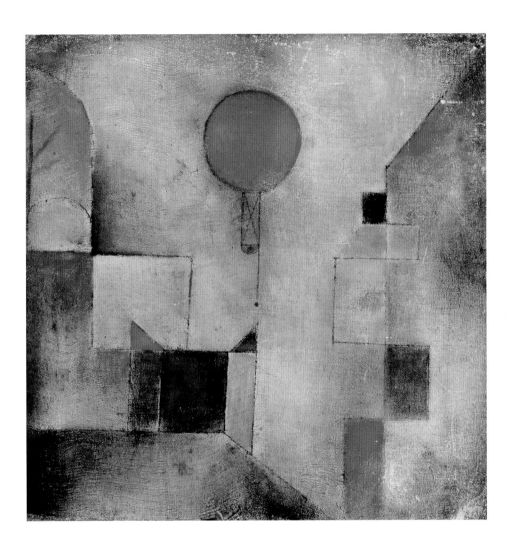

Red Balloon
1922 • oil on gauze on board • 31.7 x 31.1 cm (12½ x 12¼ in.)
Solomon R. Guggenheim Museum, New York, USA

Relieving Stress

Joan Miró *'Each grain of dust contains the soul of something marvellous.'*

Biomorphic shapes

The Spanish painter, sculptor and ceramicist Joan Miró (1893–1983) created biomorphic shapes from his imagination and stylized forms from real life. At the age of fourteen he began studying landscape painting and decorative art at the School of Industrial and Fine Arts (La Llotja) in Barcelona. Concurrently, he attended the School of Commerce, and on leaving he became an accountant. Soon, however, he had a nervous breakdown and then contracted typhoid fever, so his family bought Montroig, a farm where he convalesced and began making art. After World War I he moved to Paris, where he met Picasso and other avant-garde artists. He later recalled that he was so poor, he hallucinated through hunger. This inspired his automatism, or unconscious painting, which he believed expressed underlying truths.

Annual celebration

Strange figures are partying during Mardi Gras, the annual Roman Catholic celebration before the fasting of Lent begins. At the centre left, Harlequin, a character from Italian comic theatre, is shaped like a distorted guitar, with a blue-red ball head, moustache, pipe and admiral's hat. Miró's cat (which was always next to him as he painted) dances on its hind legs, its red and yellow face looking at the viewer. A yellow and black fish lies on a table, an ear and an eye grow out of a ladder, music

notes are on a wall, and black-and-white tubes make a wiggling cross shape in the centre. Miró explained that the black triangle symbolizes the Eiffel Tower, and the ladder represents his feeling of wanting to escape.

Self-awareness

Miró suffered throughout his life with depression, which manifested in mood swings, outbursts of temper and periods of acute despondency. He became an accountant to please his parents, but the stress of being in a career that he disliked proved too much; art helped him to become self-aware and to understand his thought processes. Automatism was his way of releasing his repressed creativity. He combined the unconscious process with a certain amount of conscious control, understanding that he needed to discipline his mind to reach the subconscious released state required to express himself, explore his feelings and experiences and so alleviate his stress. Here, the hole in Harlequin's stomach symbolizes his time as a struggling, starving artist in Paris. It can be helpful to try to become aware of one's own moods – known as metacognition – when stressed. Whatever the cause of the stress, by visualizing personal thought processes objectively, one can learn to take more control.

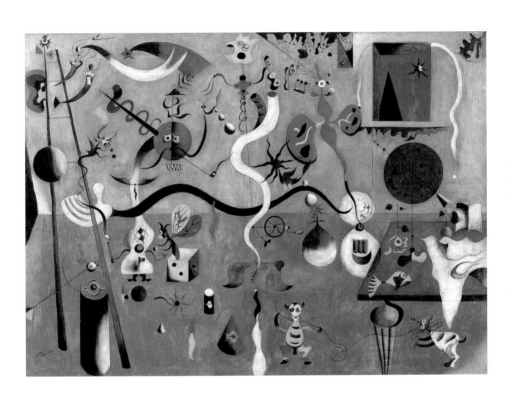

Harlequin's Carnival
1924–25 • oil on canvas • 66 x 93 cm (26 x 36⅝ in.)
Albright-Knox Art Gallery, Buffalo, USA

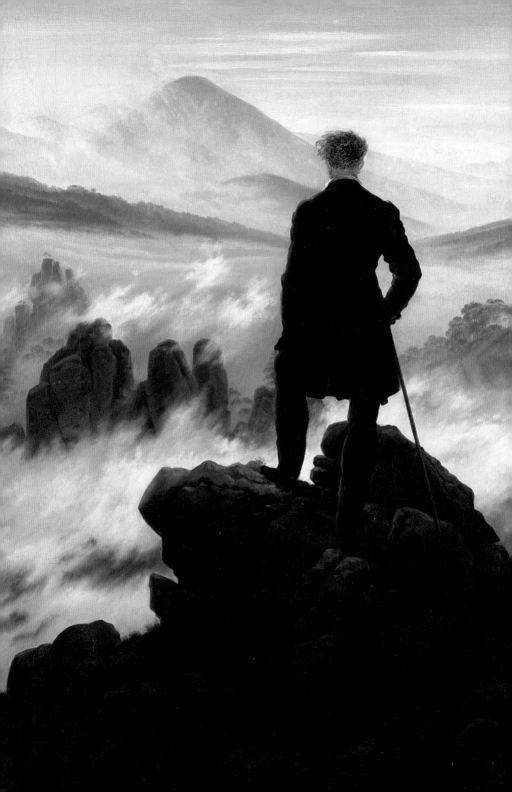

Tackling Loneliness

Many people feel lonely at times. Loneliness does not always arise from being alone, and physical proximity does not necessarily allay a sense of mental isolation, which is why so many people feel alone in cities.

Various scientific studies have been undertaken around the world to research the extent, range, cause and effects of loneliness. Some have proved that loneliness can extensively affect both mental and physical health, causing problems such as alcohol dependency, smoking and obesity. Meanwhile, a growing body of scientific evidence suggests that the creative arts are a powerful way of reducing feelings of isolation and alienation and associated negative health effects. Loneliness and the anguish commonly felt around such mental problems have often been portrayed by artists, including Vincent van Gogh, Edward Hopper, Edvard Munch, Caspar David Friedrich and Constance Marie Charpentier. Their works of art often seem like mirrors in which the viewer can glimpse their own reflection.

Wanderer Above the Sea of Fog (detail) by Caspar David Friedrich; see page 73.

Edvard Munch 'Art comes from joy and pain.... But mostly from pain.'

Morbid fascinations

Growing up in Löten, Norway, Edvard Munch (1863–1944) was surrounded by death and illness. When he was five, his mother died of tuberculosis, and nine years later his fifteen-year-old sister died of the same disease. His austere father, a fundamentalist Christian, suffered with depression. He read his children ghost stories, and Munch grew up morbidly fascinated with death and religion. He was often ill and frequently missed school. From 1879 he studied engineering, but he soon left for the Royal School of Art and Design in Kristiania (now Oslo). In 1881 he rented a studio with six other artists. Later he lived in Berlin, then Paris, and he finally settled back in Norway in 1910. The violent emotion and unconventional imagery of his paintings inspired both angry criticism and great praise.

Tongues of fire

Originally entitled *The Scream of Nature*, this iconic image is based on an experience Munch had when he heard a piercing scream while he was walking along a road that overlooked the city of Kristiania. He later recalled, 'I was walking along the road with two friends – the sun was setting – suddenly, the sky turned blood red – I paused, feeling exhausted, and leaned on the fence – there was blood and tongues of fire above the blue-black fjord and the city. My friends walked on, and I stood there trembling…I sensed an infinite scream passing through nature.' The image shown here is one of four versions; two are painted, one is in pastel and another is a lithograph.

Facing reality

Munch explained that he painted *The Scream* to represent his soul. His authoritarian father had recently died, and about fifteen years after he painted this, Munch was hospitalized for a nervous breakdown. His unrealistic style broke with tradition to express his emotions. He described his image as representing a moment of existential crisis, when the weight of the world suddenly hit him – an experience that, in his telling, sounds much like a panic attack. All his life he struggled with loneliness; he called his paintings his children. It is not necessary to suffer Munch's problems to use art as a form of companionship. Art can be enjoyed for what it conveys to each viewer personally; all art calls on memories and personal experiences, whether for those who create it or those who look at it.

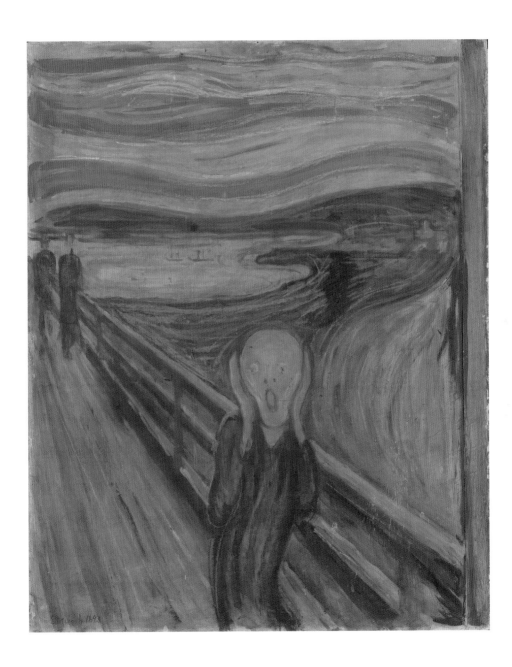

The Scream
1893 • oil, tempera, pastel and crayon on cardboard • 91 x 73.5 cm (36 x 29 in.)
National Museum, Oslo, Norway

Tackling Loneliness

Caspar David Friedrich *'The artist should paint not only what he has in front of him but also what he sees inside himself.'*

Disillusioned by materialism

Caspar David Friedrich (1774–1840) was born in Pomerania, which was then part of Sweden. His childhood was unhappy; by the time he was thirteen, his mother, sister and favourite brother had all died. After studying in Germany and Denmark, he settled in Dresden, and began his career producing watercolours, sepias, etchings and woodcuts, before working in oils. He was elected in 1810 to the Berlin Academy, and later to the Dresden Academy. He became famed for his allegorical landscapes featuring ambiguous figures and atmospheric scenery that encourages the contemplation of their possible deeper meanings. He and others working during the Romantic period were disillusioned by materialism in society, so he depicted natural, atmospheric, often haunting scenes. These were at first fashionable, but later lost popularity, and he died in obscurity.

Rückenfigur

A lone young man stands on a rocky crag, his back to the viewer. Wearing a dark green coat, he holds a walking stick and looks out over a landscape enveloped in fog. Wind catches his hair. Before him, more rocks project from the dense fog and mist. The fog seems to spread everywhere, beneath the man, before him and above him, right up to the mountains in the far distance. Friedrich included aspects of the Elbe Sandstone Mountains in Saxony

and Bohemia, rearranged for dramatic effect in the composition. The man is a Rückenfigur, a figure seen from behind; this is a common device in art that allows the viewer to project their own self or ideas on to it.

The power of nature

This painting conveys the man's solitude and the overwhelming power of nature. It conveys his contemplation, but it could also be a metaphor for an unresolved future. It may be a self-portrait or perhaps depict a universal figure; Friedrich wanted the viewer to identify with his solitary subject and to see what he sees. Concurrently, it conveys the fact that no matter how alone and vulnerable one might feel, nature will always be present in its awe-inspiring glory. However the viewer feels when looking at this, they should be reminded of the bigger picture, the wider world, and of how enjoying nature – even a small part of it – is effective in tackling loneliness. More than half the world's population lives in cities, and the modern urban environment can feel isolating. Research has shown that open spaces provide many advantages, particularly to individual health.

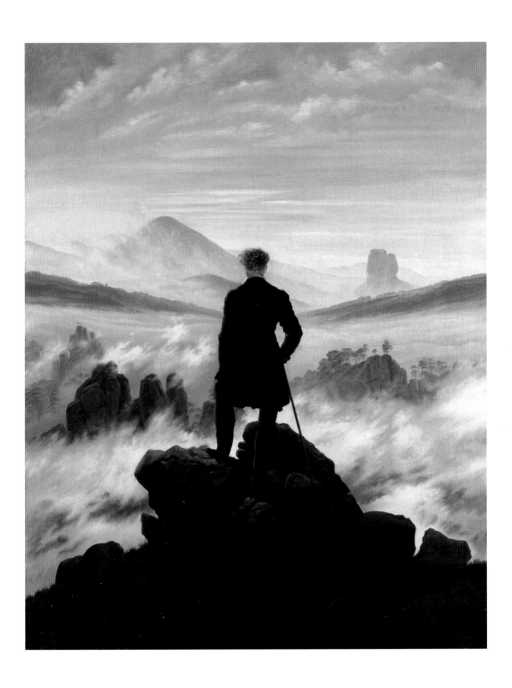

Wanderer Above the Sea of Fog
c. 1818 • oil on canvas • 94.8 x 74.8 cm (37.3 x 29.4 in.)
Hamburger Kunsthalle, Hamburg, Germany

Constance Marie Charpentier

'To give a body and a perfect form to your thought...is what it is to be an artist.' Jacques-Louis David

Emotive portraits

While information about her life is scarce, it is known that Constance Marie Charpentier, née Blondelu (1767–1849), was born in Paris and became generally perceived as one of the best portraitists of her time. She probably studied with the artist Johann Georg Wille (1715–1808) and the acclaimed Neoclassical painter Jacques-Louis David. Unusually for the time, David was supportive of female artists. Most tried to dissuade Charpentier from painting large historical canvases, which were generally considered the domain of men, and she struggled against sexism. She eventually found success with her sentimental genre scenes and portraits of women and children, which she exhibited regularly at the prestigious Paris Salon from 1795 to 1819, winning medals for some. Because of her sex and skill, several of these paintings were misattributed to David.

Solitary figure

Widely considered to be Charpentier's masterpiece, this painting was exhibited at the Paris Salon in 1801, receiving critical acclaim and an award. A lone young woman sits on the ground, dressed in a classical white chiton. Bending her head forlornly, she looks depressed, and her pose echoes an engraving by Albrecht Dürer entitled *Melencolia I* (see page 104). An allegorical figure, she almost glows against the dark, wooded background.

Her hands are limp, suggesting that she is overcome by misery. Charpentier painted this work during the French Revolutionary wars, and it conveys the collective grief of the women left behind. She could not portray strength and independence, but had to adhere to the male view of female tenderness.

Light is hope

Sometimes solitude is thrust on us, perhaps by a close relative, partner or friend's death, a pandemic, a relationship break-up, illness, an accident, moving to an unfamiliar location or job, facing war or having to leave one's home. Melancholy can permeate these moments of aloneness. At other times there is no concrete reason for such feelings, and they arise even when one is among a crowd or group. It can sometimes feel as if a light has turned off. The melancholic woman in Charpentier's image is grieving and has been captured in a moment of despair. But beyond the darkness around her, there is light between the trees that signals hope. Even though it feels unreachable, happiness still exists for her and for everyone. Wherever possible, it is worth seeking out joy and hope in art, because it is often there.

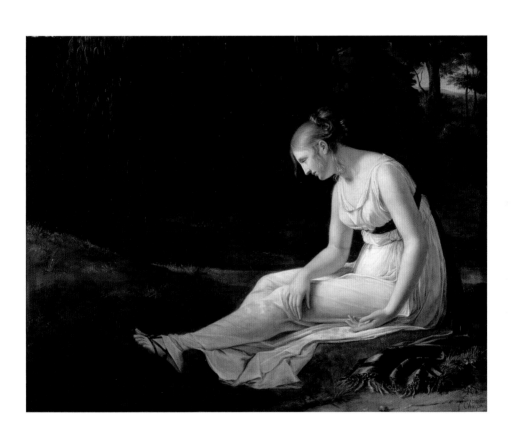

Melancholy
1801 • oil on canvas • 130 x 165 cm (51 x 64¾ in.) • Musée de Picardie, Amiens, France

Tackling Loneliness

Faith Ringgold *'Anyone can fly. All you need is somewhere to go that you can't get to any other way.'*

Story quilts

Faith Ringgold (b. 1930) grew up in Harlem, New York, during the Great Depression. After attaining a BA in fine arts and education and an MA in fine arts, she began teaching art. In 1963 she produced a series of paintings that portray the civil rights movement from a female perspective. She also began experimenting with different types of medium, and with one of her daughters she co-founded the advocacy group Women Students and Artists for Black Art Liberation. In 1972 she collaborated with her fashion-designer mother, Willi Posey Jones, creating paintings inspired by Tibetan *thangka*, an ancient form of Buddhist art. In the 1980s she began producing her 'story quilts', creating images telling stories of African-American history. In addition, she has written books for children, and her own memoirs.

Apartments in Harlem

One of Ringgold's most powerful story quilts, which she calls 'paintings', this details the lives of people in an apartment building in Harlem. Quilts were in her heritage, made by both her mother and her grandmother, and this triptych consists of three pieces of quilted fabric that she painted with acrylic and embellished with sequins and printed and dyed strips of fabric. Each façade contains curtained windows through which Black people can be seen. Beneath the windows,

Ringgold wrote three chapters of a story – The Accident, The Fire and The Homecoming – covering three decades and narrated by a woman named Gracie, about a lonely young Black boy whose life and family are negatively affected by racism and poverty.

Fostering healing

As a Black woman artist, Ringgold experienced rejection and loneliness. Her portrayals of aspects of racism and sexism reflect her personal experiences. *Street Story Quilt* explores Black American domestic life. In the three quilts, Gracie introduces ten-year-old A.J. and his grandmother Ma Teedy, who have witnessed a car accident that killed A.J.'s mother and his four brothers. In the central panel, A.J.'s drunken father accidentally causes a fire and dies in it. A.J. runs away from home and is picked up for selling narcotics to a policeman. Finally, A.J. is a successful adult, overcoming his generational trauma. Psychologists have long established that artistic expression promotes healing, and during the COVID-19 pandemic, many art museums and institutions across America – including the Metropolitan Museum of Art, where this work is displayed – set up programmes to foster healing from loneliness and isolation. Some were practical and some observational, and participants reported that the art helped them to externalize their feelings and experiences.

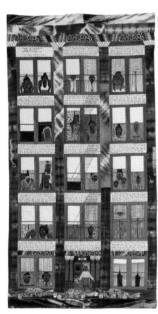

Street Story Quilt

1985 • cotton canvas, acrylic paint, ink marker, dyed and printed cotton, and sequins,
sewn to a cotton flannel backing • 228.6 x 365.8 cm (90 x 144 in.)
The Metropolitan Museum of Art, New York, USA

Tackling
Loneliness

Jane Alexander *'My work has always been a response to the social environment I find myself in.'*

Shocking events

Best known for her sculpture, Jane Alexander (b. 1959) is one of the most celebrated artists in South Africa. She became famous with her work *The Butcher Boys* (1985/86), which she created while still a student. She was born in Johannesburg and works from her own experience of growing up under apartheid – racial segregation in South Africa from 1948 to 1994 – when she witnessed street violence and more. Many of her works convey the shocking events of that time, as well as her fascination with human behaviour, historical conflict and the lack of global intervention during apartheid. She creates her figures in plaster and sometimes casts them in fibreglass before painting them in oils; she then often adds found or commissioned clothing and other objects to create thought-provoking tableaux.

Colonialism, identity and democracy

Originally made for the British Officers' Mess of the Castle of Good Hope in Cape Town, this installation is a comment on colonialism, identity, democracy and the remains of apartheid. On a large rectangle of red earth, thirteen human and animal-type figures are arranged, including a half-naked man with a linen bag over his head and a machete in his hand, dragging various farming tools behind him. He probably represents Elias Xitavhudzi, a South African serial killer who murdered with a machete. Another is Harbinger, a portent, with a human body and monkey face, standing on an orange barrel. In a Victorian silk christening dress is a small seated female figure with two gold-plated bronze horns, while other figures include Doll with Industrial Strength Gloves, Settler and Young Man.

Tolerance and communication

The flat colours and impression of silence about this work are deliberately unsettling. When Alexander began creating it, Nelson Mandela's presidency had recently ended. His election five years previously had brought apartheid to a halt, and Alexander's composition reflects on the social fragility around her after racial segregation was abolished. Referencing how apartheid affected society and how individuals lost their identity, the thirteen figures do not interact, but turn away from one another. Each seems distant and disconnected from the others. Ominous-looking boxes of TNT explosive are used by some of the figures as platforms. The work exudes loneliness and tension, and might serve to remind the viewer that these issues can be tackled through tolerance and communication.

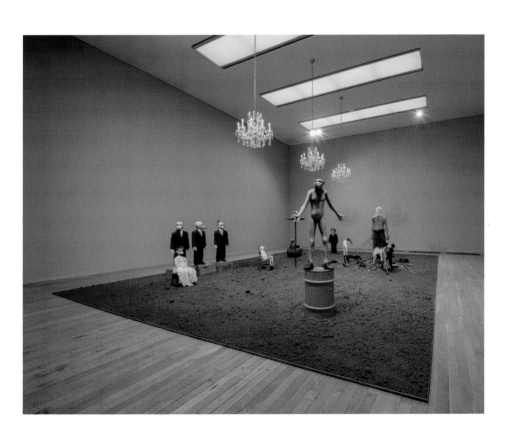

African Adventure
1999–2002 • fibreglass resin, plaster, synthetic clay, oil paint, acrylic paint, earth,
found and commissioned garments and objects • overall display dimensions variable
Tate Modern, London, UK

Tackling Loneliness

Anselm Kiefer *'What does the artist do? He draws connections. He ties the invisible threads between things.'*

Kiefer's reflections

Born in Germany in 1945, as World War II was ending, Anselm Kiefer grew up among people who avoided direct discussions about it. Many were divided in their views, and many contemporary German artists evaded the issues completely. Kiefer, on the other hand, became acclaimed for his large-scale works and panoramas filled with references to mythology, history and poetry that deliberately confronted recent events. Before he started painting, he studied law, Romance languages and literature, and his art explores a wide range of subjects, including spirituality, philosophy and mythology. Among his many influences are the Old and New Testaments, the Kabbalah, and the poetry of Paul Celan (1920–1970) and Ingeborg Bachmann (1926–1973). Many of his paintings are built up with layers of acrylic, oil paint, resin, plaster, straw, ash and lead.

Myth and memory

Its name translating as 'Man in the Forest', this painting portrays one of Kiefer's frequently used symbols: trees. A man stands in a forest, holding what appears to be a burning branch. The painting's layer is thinner and made with fewer materials than in many of his other works, but the work explores familiar themes of myth and memory, linked to German culture and history. Here, the trees dwarf the man.

Traditionally, the forest represents the idea of being lost and otherworldliness. In ancient Roman times, forests were places of sacred gathering and reverence, where gods and men often hid. During World War II many German civilians hid from bombs among the trees of the forest. Kiefer seems to portray the forest as a place of refuge as well.

Reframing aloneness

The man among the trees projects feelings of being lonely, isolated or outcast; but he is also cocooned and framed by the trees, his clothing, skin and hair tonally similar to his surroundings. Research reveals that over time, chronic loneliness increases sensitivity to, and expectation of, rejection. Those in this position can find solace in reminding themselves of their own positive qualities, things of value that they may have dismissed. This can change their approach to both social situations and the circumstance of being alone. Despite the isolation of Kiefer's man, the painting has a sense of calm and peace that viewers might take away from studying it.

Mann im Wald
1971 • acrylic on nettle cloth • 174 x 189 cm (68½ x 74⅓ in.) • Private Collection

Overcoming Sorrow

In 1513 the Italian humanist and architect Fra Giovanni Giocondo (*c.* 1433–1515) wrote in a letter, 'The gloom of the world is but a shadow. Behind it, yet within our reach, is joy. There is radiance and glory in darkness could we but see. And to see, we have only to look.' Christian art has often been produced to communicate with viewers and to help them at certain times in their lives. Catholic art in particular has explored themes of sorrow to express the 'Sorrowful Mysteries' of the New Testament and to help viewers concentrate on troubles other than their own while praying rhythmically. Even now, in a more secular age, many of these ideas can help. In *Art as Therapy* (2013), Alain de Botton (b. 1969) and John Armstrong (b. 1966) claim that art can 'teach us how to suffer more successfully'. There are numerous ways that the visual arts can assist viewers, especially by helping them to explore sorrowful feelings in a safe environment, whether by relating to or empathizing with something in a work of art, finding something new, or 'losing' themselves in the art and having a spiritual or trance-like experience through it.

Death of the Virgin (detail) by Caravaggio; see page 95.

Overcoming Sorrow

Mark Rothko *'I'm interested only in expressing basic human emotions – tragedy, ecstasy, doom, and so on.'*

Rothko's colour

Ten years after his birth in Latvia, Mark Rothko (1903–1970) and his family emigrated to the United States. Aiming to work in politics, he attended Yale University, but left after two years and later began studying at Parsons School of Design, where he was taught by Arshile Gorky. He tried various painting approaches, then in 1947 he began painting huge abstract swathes of colour, endeavouring to express and inspire emotion. This approach became associated with Abstract Expressionism, and was described as Colour Field painting. He spent the rest of his career painting variously sized fields of colour. In his later career, he worked on mural projects, including one for the Four Seasons Restaurant in the Seagram Building, New York; in the end, however, he refunded that lucrative commission, instead giving the paintings to museums. Rothko died by suicide at the age of sixty-six.

Floating rectangles

Rothko thought that the greatest paintings were those that captured a sense of stillness. Here, rectangles of colour appear to float on the canvas. He created it by layering thin washes and stains of pigment over one another and merging the edges, aiming to make his painting spiritual and detached from the world, as moving and expressive as music can be. When confronted, these large floating rectangles of modulated colour encompass the viewer. Initially, Rothko was inspired by some of the colour combinations and flat surfaces used by Henri Matisse, and he aimed to create similar all-absorbing effects. Also fascinated by the tragedies of the ancient Greek author Aeschylus (525/524–456/455 BCE) and by the ideas of the German philosopher Friedrich Nietzsche (1844–1900), Rothko sought to evoke his own powerful emotions in viewers.

Trance-like effect

Rothko's deliberately striking and sometimes dissonant colour combinations often appear to flicker and move. In the 1950s he began experimenting with more sombre colours, moving towards ideas of tragedy and sadness. If studied quietly, the large expanses of colour can generate trance-like states in the viewer. Rothko claimed that some viewers wept in front of his works, releasing underlying, suppressed feelings. He said: 'I'm interested only in expressing basic human emotions, and the fact that lots of people break down and cry when confronted with my pictures shows that I communicate those basic human emotions. The people who weep before my pictures are having the same religious experience that I had when I painted them.'

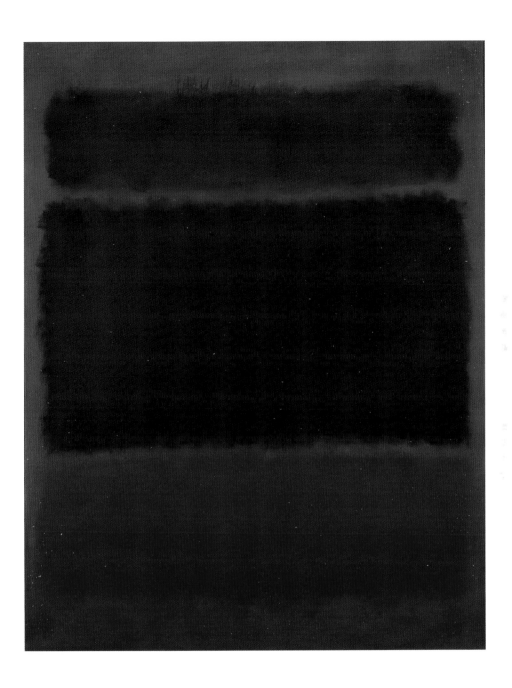

Black in Deep Red
1957 • oil on canvas • 176.2 x 136.5 cm (69½ x 53¾ in.) • Private Collection

Michelangelo *'Faith in oneself is the best and safest course.'*

'Il Divino'

Michelangelo Buonarroti (1475–1564) was a sculptor, painter, architect and poet. Born in Tuscany, he was apprenticed to Domenico Ghirlandaio (1449–1494) and then studied sculpture at the Medici Palace. Although maintaining that he was a sculptor, Michelangelo was equally accomplished at painting and architecture; he gained the nickname 'Il Divino' (The Divine One), his style was described as having *terribilità* (awesomeness), and he became the first artist to have biographies published during his lifetime. Despite preferring sculpture, he painted the vast ceiling of the Sistine Chapel in Rome for the Pope, including 343 life-sized figures and *The Last Judgement* on the altar wall. He created two of his best-known sculptures, *Pietà* (Pity) and *David* (1501–4), before he was thirty, and he became the architect of St Peter's Basilica when he was seventy-four.

Personifying despair

After overhearing that this *Pietà* (one of three he sculpted) was being credited to a competitor, Michelangelo signed it – the only time he ever did so. It represents the Madonna holding Christ in her arms after the Crucifixion. Until Michelangelo created this work, the theme of sorrow had not been common in Italy. The grieving Mary appears ageless, her head tilting slightly over her son's lifeless body, her hand held out in despair. Michelangelo defended his choice to portray her as youthful, declaring it a sign of her purity. The artist, art historian and biographer Giorgio Vasari (1511–1574) wrote of the work's 'divine beauty', as it amalgamates Renaissance ideals of classical beauty with naturalism. To balance the composition, Michelangelo made Mary's lap far larger than it would have been, yet it appears natural.

Beyond words

The scene of the *Pietà*, in which Christ's body is placed across his mourning mother's knees, is not mentioned in the Bible, but during the medieval period it was described as one of the 'Seven Sorrows of the Virgin'. One of Mary's titles is Queen of Martyrs, suggesting that her martyrdom is greater than that of others. In Catholic art, martyrs are generally represented with the instruments of their suffering, and here Mary holds her dead son. When grieving or other sorrow is beyond words, images can help to express or absorb some of the deepest feelings, to console even if only for a few moments. Art full of emotion, such as this, can help to release deep feelings of sadness and the physical symptoms of distress, depression and anxiety associated with those feelings.

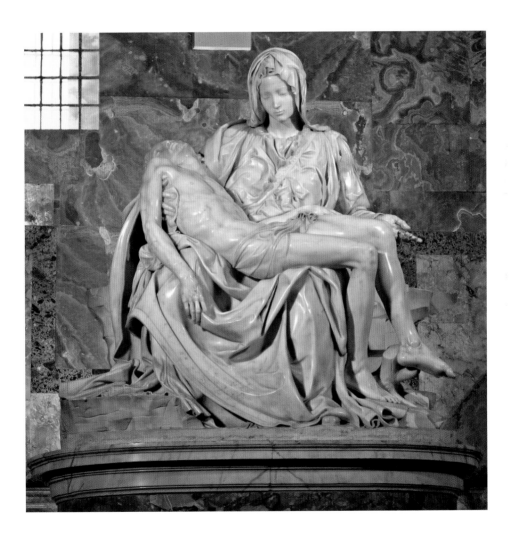

Pietà
1498–99 • marble • 174 x 195 cm (68½ x 76¾ in.) • Basilica di San Pietro, Vatican City, Italy

Overcoming Sorrow

Pablo Picasso *'I love [art] for the buried hopes, the garnered memories, the tender feelings it can summon at a touch.'*

Leader of the avant-garde

The most famous artist of the twentieth century, Pablo Picasso (1881–1973) was a painter, draughtsman, sculptor and ceramicist who created more than 20,000 works over his long career, and who changed art history profoundly. A child prodigy, he used his originality, versatility and energy throughout his life to leave an unparalleled legacy. Among many other things, he experimented with various media, co-founded the movement that came to be known as Cubism, and introduced collage to fine art. He grew up in Spain, and was accepted at the School of Industrial and Fine Arts (La Llotja) in Barcelona at the age of fourteen, surpassing all the older students. After moving to Paris in 1900, he became recognized as a leader of avant-garde art, changing his approach regularly and radically. Several of his styles were labelled, among them his Blue, Rose and African periods.

Symbolizing pain

Painted in response to the Nazis' aerial bombing of the Basque town of Guernica during the Spanish Civil War (1936–39), this painting conveys a universal image of suffering. The model was Dora Maar, Picasso's mistress at the time, and the image recalls the Catholic Mater Dolorosa (Our Lady of Sorrows) crying over her dead son (see page 91). Bold colours and lines create angular shapes and planes, depicting the face from various viewpoints. Unsuspecting of the forthcoming tragedy, she wears a jaunty hat, compounding the poignancy. Her handkerchief appears to be turning to ice or glass to symbolize her pain, while her pupils suggest the shapes of the enemy planes overhead.

Hope

Using his early analytical Cubist style, Picasso painted this work with angular, jagged fragments. The painting embodies sorrow and the grief of innocent civilians during war, showing the intensity of the woman's pain. Alternatively, it could be a self-portrait, conveying Picasso's distress at learning that his country was being destroyed by civil war. (He vowed never to return to Spain while General Franco remained in power.) Either way, he compels us to experience the raw feelings that this woman portrays, and to feel grateful that we can share our emotions. Picasso's friend and biographer Roland Penrose (1900–1984), who owned the painting, believed that it represented hope, including the healing power of mourning. In this light, the woman's right ear becomes a bird drinking her tears, and the flower in her hat a sign of new life.

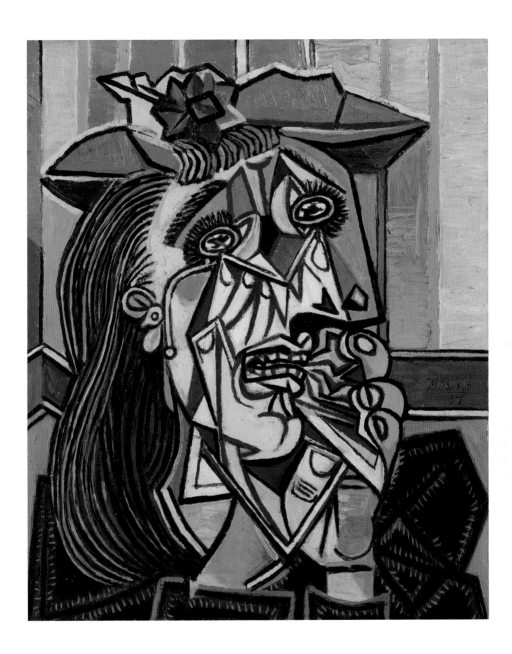

Weeping Woman

1937 • oil on canvas • 61 x 50 cm (23¼ x 19¾ in.) • Tate Modern, London, UK

Aelbrecht Bouts *'He healeth the broken in heart, and bindeth up their wounds.'* Psalm 147:3

Artist's contemplation

Aelbrecht (sometimes spelt Albert, Aelbert or Albrecht) Bouts (before 1473–1549) was born in Leuven, Belgium, into a family of painters. His father and elder brother were artists, and in 1475 Aelbrecht took over his father's workshop. Most of his works were created for Christian worship, and involved distinctive interpretations of devotional subjects, often expressing misery. It was important in the Low Countries at that time for artists to help worshippers understand the scriptures, and Bouts developed an exacting technique, including smooth contours, meticulous details and a limited palette. Many of his paintings were created to encourage contemplation, and his work became so popular that he expanded his workshop and produced huge numbers of similar paintings.

Universal grief

Encouraging the viewer to identify with Mary's suffering after her son had been crucified, this painting expresses universal feelings of sadness and grief. The theme of Mary's sorrow was popular in parts of northern Europe during the fifteenth century because it adhered to the religious reform movement known as Devotio Moderna (Modern Devotion). Followers were encouraged to pray privately in front of devotional images, and Bouts was in demand for these, especially for works of

art on the subject of sorrow. In picturing the Virgin at her lowest, the artist has illustrated Psalm 147:3, 'He healeth the broken in heart, and bindeth up their wounds.' Despite her grief, Mary remains dignified. The viewer's compassion is aroused through her unhappy eyes and glistening tears.

Releasing tension

Grief and mourning are extremes of sorrow and sadness, and they can be life-altering. We all respond to these emotions differently, but there are universal ways of coping and beginning the healing process. Grief can change our behaviour, lower our self-esteem and increase depression, but studies have found that the visual arts are especially effective in easing symptoms of misery, and can open up avenues through which we can explore and express these feelings of loss, setting us on a path to acceptance and healing. Bouts understood how, by living in the moment while contemplating a work of art, tension is released, allowing natural healing processes to take place.

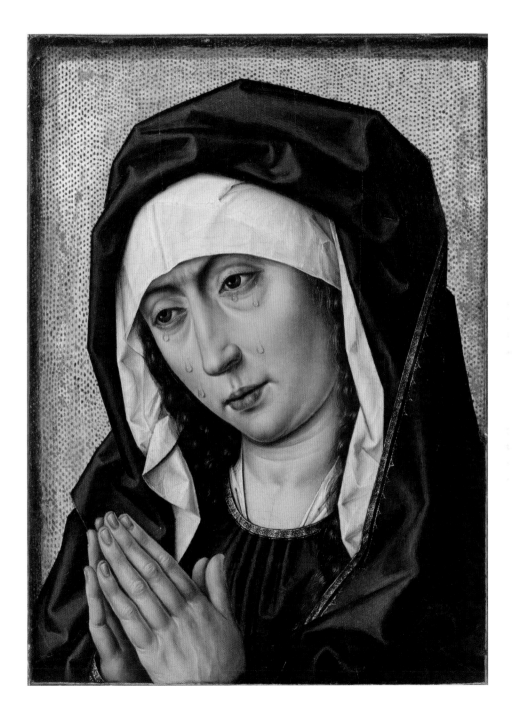

The Mater Dolorosa
mid-1490s • oil on oak panel • 37.9 x 27 cm (15 x 10½ in.)
Harvard Art Museums, Cambridge, Massachusetts, USA

Overcoming Sorrow

Masaccio *'Humanism is a rational philosophy informed by science, inspired by art, and motivated by compassion.'*

The American Humanist Society

Realism and perspective

Through his innovative realism and perspective, Masaccio (1401–1428) is recognized as one of the greatest artists of the Early Renaissance. He was influenced by Donatello (*c*. 1386–1466), who produced lifelike sculpture, and the architect Filippo Brunelleschi (1377–1446), who worked out the concept of linear perspective. 'Masaccio' is a nickname meaning 'clumsy or messy Tom', probably a reference to his appearance and lack of attention to anything but painting. Little is known about his early life, but in 1422 he joined the Florentine painters' guild, Arte dei Medici e Speziali, as an independent artist, and in 1423 he travelled to Rome to study classical statues and produce a large altarpiece with Masolino (1383–*c*. 1440–47). He later painted several altarpieces in Florence. He died in Rome at the age of twenty-six, probably of the plague.

Torment and suffering

The work shown here, one of Masaccio's best-known scenes, depicts the moment in the Bible that Adam and Eve were cast out of the Garden of Eden for disobeying God's orders. Making his figures look real, Masaccio broke with the favoured, more rigid Gothic style. Adam and Eve sob and lament as they leave the garden, their expressions distraught. The impression of human torment and suffering portrayed here was ground-breaking for

the time; the realities of human sorrow had rarely been portrayed before, so this portrayal of personal emotion made the work hugely influential, even inspiring Michelangelo's frescos in the Sistine Chapel. Both poses come from classical statues. Eve's derives from the Venus Pudica, while Adam's torso was probably inspired by the Apollo Belvedere statue in the Vatican.

Humanism

Masaccio was involved with the new humanist movement that was gaining momentum among the educated classes in Italy during the fifteenth century. Humanism is based on putting humans, rather than God and the afterlife, at the centre of everything. It is a positive attitude to the world, a belief that each person can influence their own and others' lives by the way they live. It places a greater emphasis on earthly pleasures and social values than do Christian beliefs, which prepare for a better life to come. In the light of this, Masaccio's *Expulsion* presents the Bible story as a moral tale, showing the pain, misery and shame Adam and Eve experienced after eating the forbidden fruit. Humanism suggests that one should focus on seeking personal happiness – and not be afraid of allowing oneself to be happy – as well as having empathy and compassion for others.

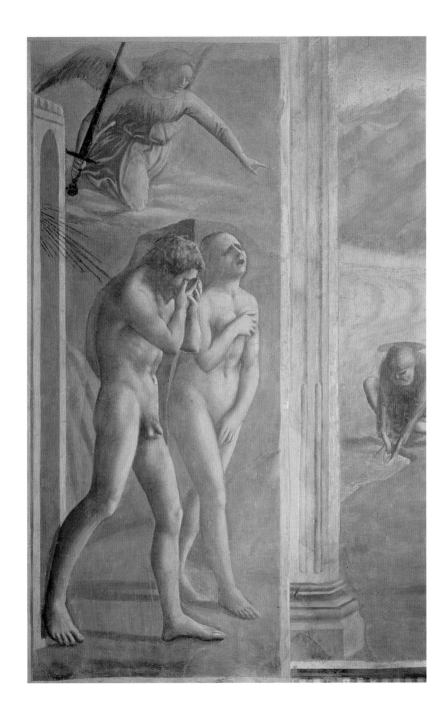

The Expulsion from the Garden of Eden

1425–27 • fresco • 208 x 88 cm (82 x 34⅔ in.) • Cappella Brancacci,
Chiesa di Santa Maria del Carmine, Florence, Italy

Overcoming Sorrow

Caravaggio *'The anguish of those present seems to have an infinite and indelible character.'*
Roberto Longhi

Dramatic effects

Michelangelo Merisi da Caravaggio (1571–1610) created a unique style of painting, depicting biblical events as if they were contemporary. After being orphaned, he was apprenticed to the painter Simone Peterzano (*c.* 1540–*c.* 1596) and then moved from Milan to Rome. As an independent artist, he painted naturalistically with dramatic lighting effects, and from about 1600 to 1606 he was the most famous painter in Rome, although his use of peasant models for holy figures offended many. He attained notoriety for frequent brawls, and in 1606 he killed a man and was banned from Rome. He moved to Naples, where he was protected by the Colonna family, but in 1608 he was again arrested for a brawl, and exiled to Sicily. Caravaggio died in mysterious circumstances when returning to Rome to receive the Pope's pardon.

Discarding iconography

Commissioned by the papal lawyer Laerzio Cherubini (*c.* 1556–1626), this work was made for his chapel in the church of Santa Maria della Scala in Rome. The painting was rejected, however, being considered inappropriate. Several scholars have suggested that the Virgin was modelled by a prostitute, which offended the friars, as did the fact that her ankles were exposed and her body swollen. Under a red canopy, the Apostles gather around her body. Light shines through a high window, highlighting their heads and the upper part of Mary's body, which is dressed in a contemporary red gown. Caravaggio has completely discarded the iconography traditionally used to show Mary's holiness. St John the Evangelist is close by, while Mary Magdalene sobs, holding her head in her hands.

Darkness into light

This painting embodies grief. Grief-stricken figures surround the Virgin's body, their faces hidden. Dazzling light and deep shadows express the powerful emotions. Caravaggio's original, dramatic use of chiaroscuro and tenebrism, or extreme contrasts of light and darkness, made him highly influential for centuries. He created this painting to be viewed in a dark, candlelit church so that the light elements would shine out. Darkness and light have long been used in art as metaphors to help those who are depressed, grieving, suicidal or sorrowing in other ways. As the English preacher Thomas Fuller wrote in 1650, 'It's always darkest before the dawn.'

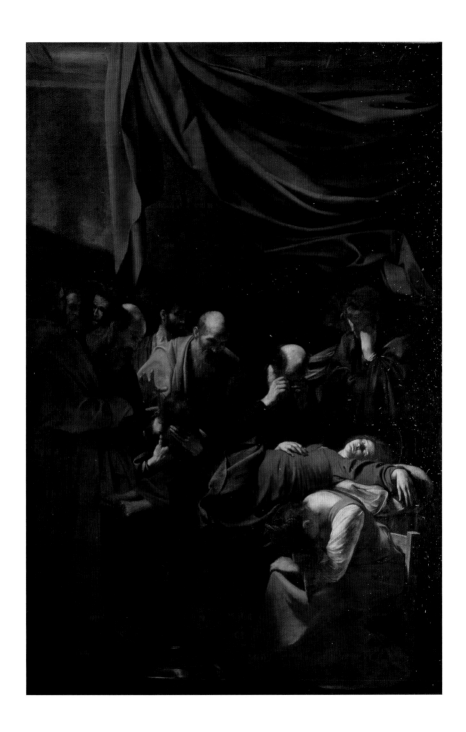

Death of the Virgin
1602–6 • oil on canvas • 369 x 245 cm (145¼ x 96½ in.) • Musée du Louvre, Paris, France

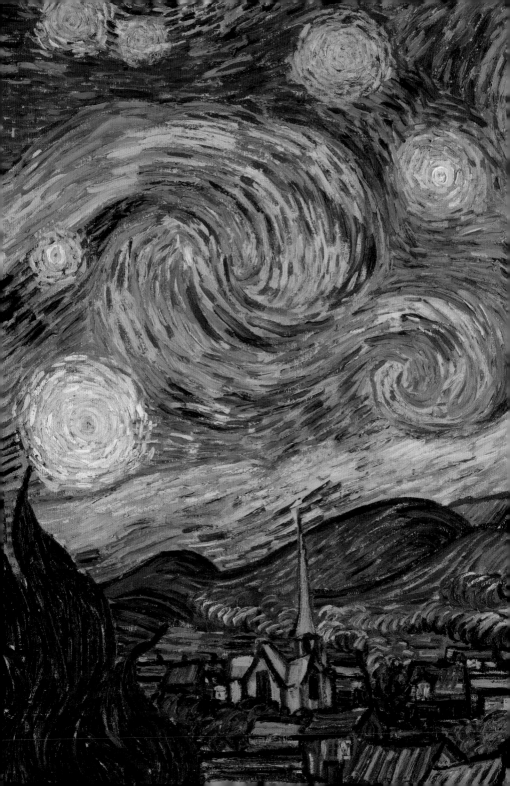

Inspiring Self-reflection

In general, through their art, artists attempt to make sense of the world and of how humans live. Viewing or making art naturally stimulates the mind, and through the self-reflection or introspection it instigates, it can help the viewer to gain greater awareness of self and of the world.

Each person's behaviour creates their identity in society, but through self-reflection – concentrating on true outlooks, values, attitudes, beliefs and behaviour – everyone can be more in tune with themselves, achieve their greatest goals and ambitions, be more respectful of and sensitive to the feelings of others, and manage their emotions and reactions better. Artists frequently concentrate on their weaknesses and strengths, and studying different works of art can help the viewer to do the same for themselves. For example, Barbara Hepworth created art that explored nature and music, two areas of her life that were important to her; Vincent van Gogh focused on bright colours; and Aaron Douglas contemplated aspects of his heritage. These are all areas with personal connections to the artists, which is an essential element of effective self-reflection.

The Starry Night (detail) by Vincent van Gogh; see page 103.

Shen Zhou *'He who requires much from himself and little from others, will keep himself from being the object of resentment.'* Confucius

Confucianism and independence

A leading member of a group of artists known as the Wu School, in which painting was a meditation rather than an occupation, Shen Zhou (1427–1509) was born into a wealthy family in Jiangsu province, China. Since his family was prosperous, he had no need of patrons, and because his mother's care was assured even after his father's death, he continued painting without restrictions. His education and artistic training instilled in him a reverence for his country's historical traditions, so he followed the artistic approach of China's Yuan Dynasty (1206–1368) and his heritage of orthodox Confucianism, while also experimenting with his own styles. He became most famous for his landscape and flower paintings, as well as his collaborations with others in the production of paintings, poetry and calligraphy.

Delicate and harmonious

Shen painted this scroll to celebrate his teacher Chen Kuan's seventieth birthday. Portraying the revered Mount Lu near Chen's home town, Shen conveys its grandeur, steepness and flowing waterfalls, and the clouds that envelop it for almost 200 days each year. About 1,500 m (nearly 5,000 ft) above sea level, Mount Lu and the surrounding region constitutes one of China's spiritual centres, containing many Buddhist and Taoist temples and Confucianist landmarks.

In this delicately detailed, harmoniously balanced composition, Shen has built up a sense of texture using various expressive brush marks. At the foot of the mountain, near the cascading water, a tiny man looks up – indicating that humans are a small part of nature. Unlike Western art, paintings in China were created for private contemplation, to enrich the viewer's spirit.

Inner peace

Shen believed that painting was a form of meditation and an extension of himself. Many studies have been conducted to ascertain how meditation may help various health conditions, such as high blood pressure, depression and insomnia. It has long been accepted as a way of increasing calm, improving psychological balance and boosting general health. Shen's approach to painting enabled him to balance his mind and brain, and increase his sense of calm. Numerous other artists have achieved this, including Picasso, who reflected, 'My solace and peace are found with my personal challenge of creating what I see and feel…. I can stand for hours concentrating on painting, I find inner peace and smile with my accomplishment, even if small.' Similarly, whether through time spent creating art or concentrating on someone else's, it is possible to help oneself to inner peace.

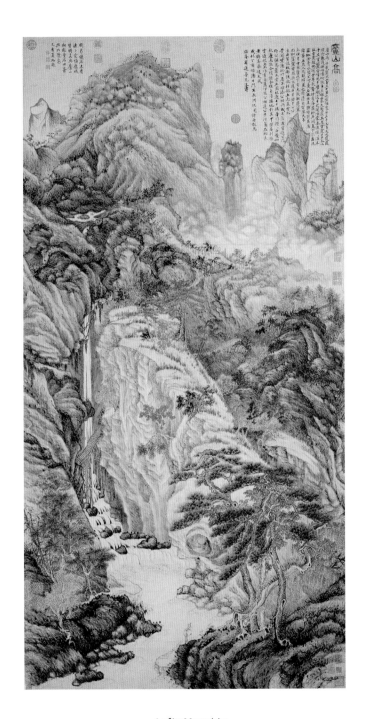

Lofty Mount Lu
1467 • ink on paper, hanging scroll • 193.8 x 98.1 cm
(76¼ x 36⅔ in.) • National Palace Museum, Taipei, Taiwan, China

Barbara Hepworth *'The naturalness of life...the sense of community is, I think, a very important factor in an artist's life.'*

Hepworth's landscape

While living in St Ives, Cornwall, a popular colony of artists, Barbara Hepworth (1903–1975) became internationally renowned for her modernist sculpture. As a child growing up in Yorkshire, she was awarded music prizes, then from 1920 she studied sculpture at Leeds School of Art, where she met fellow sculptor Henry Moore (1898–1986). She continued studying at the Royal College of Art in London, and then visited Florence and Rome. Back in England, she began to carve directly into stone – an unusual practice at the time – and in 1931 she met the man who would become her second husband, the painter Ben Nicholson (1894–1982). They lived and worked together from 1932, and spent time travelling around Europe, meeting avant-garde artists, including Picasso and Sophie Taeuber-Arp (1889–1943). The rugged Cornish landscape and the company of other artists inspired Hepworth.

Pierced forms

Made in Hepworth's London studio a few years before she moved to St Ives, this is one of her original 'pierced' forms. Although they are all abstract, they also have connections with nature. In her autobiography she wrote, 'The closed form, such as the oval, spherical or pierced form…translates for me the association and meaning of gesture in landscape.' In 1925–26 she had learned to carve marble in Rome, and she first began piercing her sculpture in 1932. Both her carving and piercing, and the abstract forms of her work, gave her a sense of freedom. This white marble form is a half sphere pushed slightly backwards so that the flat surface is at an angle and can be seen easily when walking around the work.

Benefits of group thinking

Since 1885, St Ives in Cornwall had been a popular artists' colony, where artists and art students of different nationalities gathered to learn and paint. Valued for the special quality of its light and its four sandy beaches, St Ives was served by a relatively new rail link, which made it easily accessible. The first artists there were British, French, American, Finnish and Swedish, and the colony soon acquired an international reputation. However, its popularity was waning by the time Hepworth arrived in August 1939, and she helped to rebuild it, attracting new artists to settle there and working among them for thirty-six years. The benefits of reflecting on thoughts and feelings with supportive people are many. Friends and colleagues can advise, challenge and offer opinions, which can bring greater awareness or develop perspective more fully.

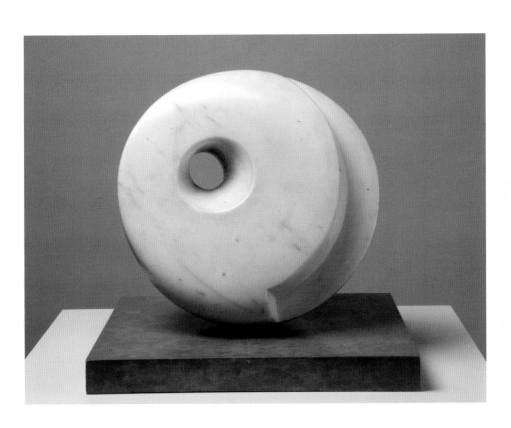

Pierced Hemisphere I
1937 • marble • 35 x 38 x 38 cm (13¾ x 15 x 15 in.) • The Hepworth Wakefield, Yorkshire, UK

Vincent van Gogh *'I'm struggling and striving to make something myself that is realistic and yet done with sentiment.'*

Van Gogh's travels

Unappreciated during his lifetime, Vincent van Gogh (1853–1890) is now famous for his art and his life. Born in the Netherlands, he took numerous jobs – but was dismissed from most – and became involved in unsuitable romances. In 1880 he became an artist, supported financially by his brother Theo. His early paintings were dark, but after living in Paris he shortened his brush marks and brightened his colours. He moved to Arles in the South of France, hoping to start an artistic community, but only Paul Gauguin (1848–1903) joined him there. They quarrelled, and Van Gogh cut off his own ear. He was treated in an asylum for complex psychiatric ailments. In 1890 he moved to Auvers-sur-Oise, but within weeks he had shot himself, and he died two days later in Theo's arms.

Landscape of emotions

Painted during his stay at an asylum near Saint-Rémy-de-Provence, this is one of Van Gogh's most famous works. At the asylum, he was diagnosed with epilepsy and paranoia, but he painted when he was lucid. This painting evolved from his observations, imagination, memories and emotions. In the swirling impasto sky, a crescent moon and stars are surrounded by concentric circles of white and yellow. Below, a village nestles in darkness; a tall church steeple points to the sky. In the foreground, a flame-like, silhouetted cypress tree reaches the top of the canvas, connecting the land with the sky, which can be interpreted as heaven and Earth, or Van Gogh and the rest of the world.

Natural light and colour

Before he moved to Arles, Van Gogh had never been so far south, and while he was there he had some time for self-reflection. The sunlight reminded him of the Japanese prints he collected, and many of his letters from Arles acknowledge his appreciation of the local light and colour. He loved the vibrant hues of the landscape, and spent long days painting outside, applying bright yellows, oranges, blues and greens to his canvases. While in the asylum, he had even more time for self-reflection, and painted numerous canvases. Despite the fact that this scene depicts the time just before daybreak, he strove in it for what he called 'the high yellow note' – vivid colour and emotion in perfect harmony. Yellow, for him, stood for life and energy.

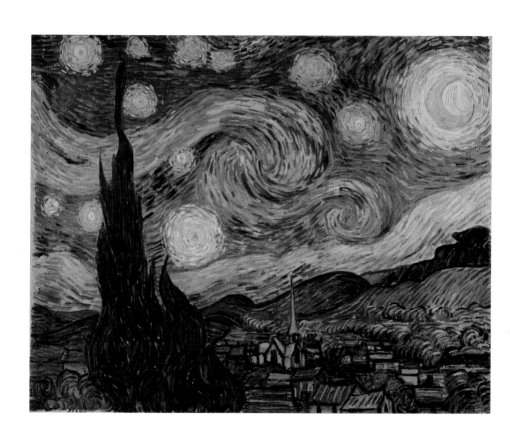

The Starry Night
1889 • oil on canvas • 73.7 x 92.1 cm (29 x 36¼ in.) • Museum of Modern Art, New York, USA

Inspiring Self-reflection

Albrecht Dürer *'I shall let the little I have learned go forth into the day in order that someone better than I may guess the truth.'*

Revolutionary printmaking

The painter, printmaker, draughtsman and writer Albrecht Dürer (1471–1528) was born in Nuremberg, at that time an important artistic and commercial centre. Initially apprenticed to his goldsmith father, Dürer then apprenticed with the local painter and printmaker Michael Wolgemut (1434–1519). He spent some time in Italy, learning much from the Italian Renaissance, and became successful for painting and writing, but especially for printmaking, which he revolutionized through his use of tonal contrast and drama. He wrote several books, including *Vier Bucher von menschlicher Proportion* (Four Books of Human Proportion, 1528), and his abilities, ambition and intelligence attracted the friendship of some of the foremost figures in German society. He became court artist to the Holy Roman emperors Maximilian I and then Charles V, and made portraits of some of the most prominent people of the period.

Inner thoughts

One of three large prints known as Dürer's *Meisterstiche* (master engravings), this is a depiction of the artist's inner thoughts. In medieval philosophy, everyone was believed to be controlled by one of the four humours, and the least pleasant humour was melancholy, associated with black 'gall' or bile. Melancholics were thought most likely to become insane, and also most likely to be creative geniuses. In the image, Melancholy is represented by a winged woman, her head resting on her hand. She sits with a closed book in her lap, holds a pair of compasses and is surrounded by other tools and instruments associated with geometry. Behind her is a windowless building with a ladder leaning against it. A cherub sits scribbling on a tablet.

Gaining inspiration

In Dürer's time, the arts were believed to evolve from the imagination, which was one of the three categories of genius. As one of the four humours, melancholy was believed to cause depression and sometimes generate hallucinations and delusions. This engraving has been interpreted as Melancholia personified, waiting for inspiration, rather than an image of depression. Many Renaissance thinkers linked the state of melancholia with the creative imagination, believing that artists must spend time in contemplation if their original thoughts are to be allowed to form. It has long been accepted that self-reflection can help mental health and lead to inspiration. To use self-reflection in this way, instead of worrying about what may have gone wrong, focus closely on positive memories.

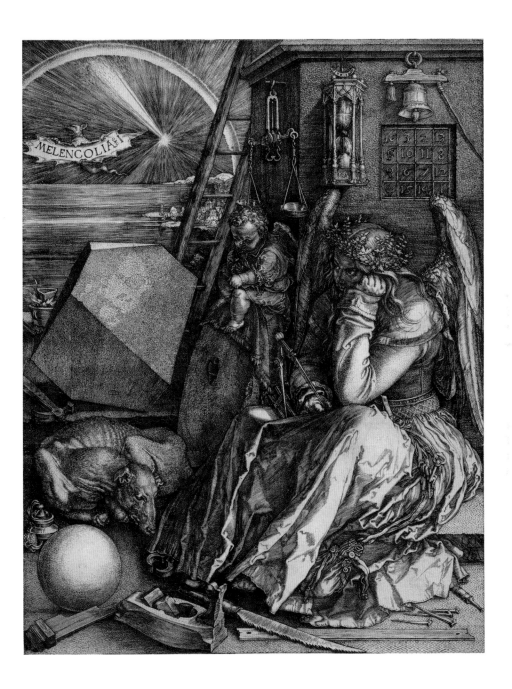

Melencolia I
1514 • engraving • 24 x 18.5 cm (9½ x 7½ in.) • The Metropolitan Museum of Art, New York, USA

Inspiring Self-reflection

Aaron Douglas *'Let's do the impossible. Let's create something transcendentally material, mystically objective. Earthy. Spiritually earthy. Dynamic.'*

The Harlem Renaissance

The painter, illustrator and teacher Aaron Douglas (1899–1979) was a key figure in the Harlem Renaissance. His pared-down style addressed the African-American experience, particularly race and segregation in America. Born in Kansas City, Douglas studied at the University of Nebraska, then taught in Kansas City. In 1925 he moved to Harlem, New York, where he was commissioned to create murals for public buildings, and illustrations and cover designs for various Black publications. He later created murals for Fisk University in Nashville, Tennessee, and others in Chicago and Dallas. He lived in Paris for a year, then returned to Harlem, where he painted more murals and supported young African-American artists through the Harlem Artists Guild that he helped to establish. He founded the art department at Fisk University in 1944, and taught there for decades.

God's Trombones

During the 1920s and 1930s an unprecedented outburst of creative activity among African Americans occurred in all disciplines of art. It was called the Harlem Renaissance, and Douglas became one of its leaders. His painting style assimilates elements of Art Deco, ancient Egyptian and African art, modernism and jazz music. Many of his figures are faceless, translucent silhouettes. The image opposite is the last of eight illustrations he made for a collection of poems by James Weldon Johnson (1871–1938), *God's Trombones: Seven Negro Sermons in Verse* (1927). The largest figure, a Black Angel Gabriel, stands with one foot on the Earth and the other on the sea, summoning the living and the dead to judgment with his trumpet call. The smaller figures represent humanity.

Spiritual emancipation

The period from about 1916 to 1970 is called the Great Migration, when, driven by lack of work and by segregationist laws, some six million African Americans moved from the rural South to cities in the North, Midwest and West of the United States. This resulted in the development of a new urban African-American culture. As part of the Harlem Renaissance, many African Americans became more reflective about their circumstances. In his book *The New Negro* (1925), the philosopher and arts patron Alain LeRoy Locke (1885–1954) observed that 'we are achieving something like a spiritual emancipation'. Awareness of the changing world led these Harlem inhabitants to become especially conscious of discrimination and to assert their identities. Douglas celebrated his heritage through his art, a practice that might inspire reflection on identity, heritage and self.

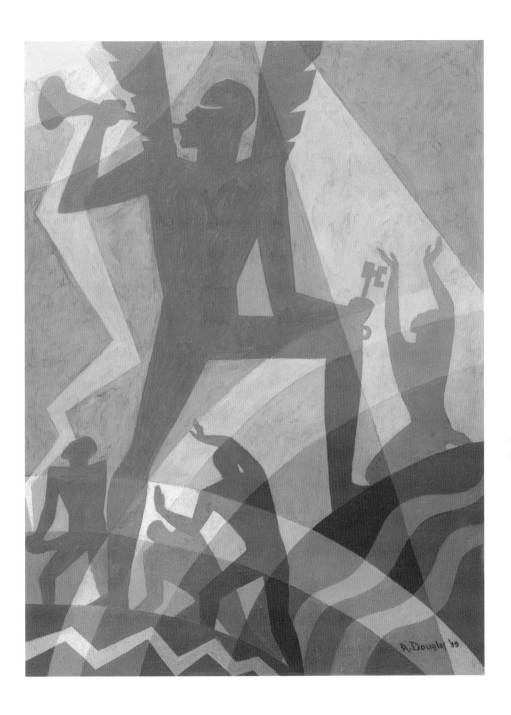

The Judgement Day
1939 • oil on tempered hardboard • 121.9 x 91.4 cm (48 x 36 in.)
National Gallery of Art, Washington, DC, USA

Johannes Vermeer *'By art alone we are able to get outside ourselves, to know what another sees of this universe.'* Marcel Proust

Vermeer's light

Despite the brevity of his career, the fact that he never left his native Delft and the relatively few works he painted, Johannes (Jan) Vermeer (1632–1675) is seen as one of the greatest masters of Dutch seventeenth-century art, often referred to as the Dutch Golden Age. Little is known about his life and education, although he was apprenticed to a few artists and also worked as an art dealer. At the age of twenty-seven he was admitted to the Guild of St Luke, a trade association for artists. His first works were large-scale biblical and mythological scenes, but later he painted small images of everyday life, bathed in pure light. He worked slowly, using expensive pigments and almost imperceptible brush marks. He died in debt at just forty-three, leaving a wife and eleven children.

An introspective moment

A woman in a fur-trimmed blue jacket stands at a table in the corner of a room. On the table is a blue cloth and an open jewelry box with two strands of pearls and a gold chain. Scales in her right hand are balanced, implying the state of her mind. Behind her, on the back wall, is a large painting of the Last Judgment, framed in black, and soft light comes through the window. It is a private, introspective moment. In the light of Vermeer's Catholicism, the Last Judgment and the scales suggest that the woman is examining her conscience. The juxtaposition of material possessions (the gold and pearls) and the biblical painting reminds the viewer of the dire consequences of materialism and greed.

Self-knowledge

In many religions, by examining one's conscience and behaviour, worthwhile and effective choices can be made in life. *Woman Holding a Balance* is an allegory, urging the viewer to act with restraint, kindness and compassion, and not to be greedy or focus on worldly things. In addition, the woman is pregnant, which may imply that we all have responsibilities towards future generations. The painting is an aid to contemplation, then, an encouragement to lead a considerate life. Some scholars have suggested that the mirror on the wall reflects the woman's self-knowledge. We can use self-reflection to gain self-knowledge, which includes recognizing the reasons for thinking, feeling and acting in a certain way. By becoming conscious of what drives us, we will be able to make changes that help us to improve our lives.

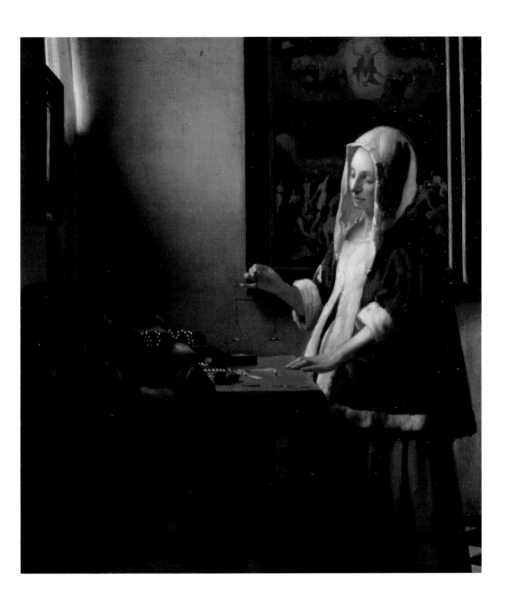

Woman Holding a Balance
c. 1664 • oil on canvas • 39.7 x 35.5 cm (15½ x 14 in.)
National Gallery of Art, Washington, DC, USA

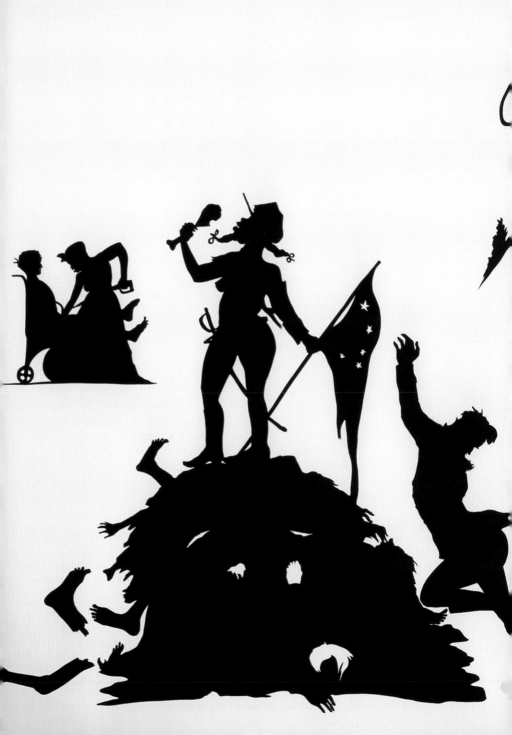

Learning Empathy

Educators have long been using the arts and humanities to teach empathy. The dictionary defines this quality as 'the ability to share someone else's feelings or experiences by imagining what it would be like to be in that person's situation'. Yet the word was created only in the late nineteenth century. It began with the German doctor Wilhelm Wundt (1832–1920), one of the founders of modern psychology, and the German philosopher Theodor Lipps (1851–1914). Lipps said that empathy was stimulated in the viewer by the act of observing. The Anglo-Canadian psychologist and novelist Professor Keith Oatley of the University of Toronto has conducted research into how readers and viewers learn empathy from novels and art. He explains, 'In empathy, one has an emotion which is similar to that of another and feels something of that person's inner experience. Psychological research has shown that literary art enables people to increase their empathy and understanding of others, and it is likely that this also happens with paintings and sculptures that depict human beings in states such as joy, bewilderment, and anguish.' You may be surprised at some artists who are able to arouse empathy in the viewer, and in this chapter we consider the wide range of ways this is done by artists, including Kara Walker, Elizabeth Catlett and Henry Ossawa Tanner.

The Jubilant Martyrs of Obsolescence and Ruin (detail) by Kara Walker; see page 117.

Henry Ossawa Tanner *'My effort has been…[to] give the human touch to convey to my public the reverence and elevation these subjects impart to me.'*

Tanner's awards

The first African-American painter to gain international acclaim, Henry Ossawa Tanner (1859–1937) was born in Pittsburgh and moved to Philadelphia when he was young. He studied at the Pennsylvania Academy of the Fine Arts, and with the renowned figurative artist Thomas Eakins (1844–1916). In 1891 he moved to Paris, where he spent most of the rest of his life, becoming part of the art community. His work was accepted into the prestigious Salon, and the American department-store magnate and art patron Rodman Wanamaker (1863–1928) paid for him to visit the Middle East. During World War I Tanner worked for the Red Cross Public Information Department and also painted images featuring African-American troops. In 1923 he was awarded the highest French order of merit, becoming a Knight of the Legion of Honour.

Biblical realism

Soon after returning to Paris from his Middle Eastern trip in 1897, Tanner, the son of a minister in the African Methodist Episcopal Church, painted this unconventional image of the moment when the Angel Gabriel announces to Mary that she will bear the Son of God. Mary is a poor, young Jewish woman dressed in Middle Eastern peasant's clothing, with no halo. Gabriel appears as a shaft of light. For a Realist painter, depicting something supernatural was challenging, but Tanner painted the angel and Mary as he thought they would have looked. Unlike most previous Christian representations, this Mary has dark hair and Middle Eastern skin tones, while her bed is dishevelled and the room bare – very different from the opulence in which she is traditionally shown.

Arousing compassion

The empathy Tanner conveys through his religious stories is tangible. A man who grew up with racism and prejudice, he did not portray Mary as a White woman, as most European artists had done before him, but considered how she would really have looked and how poor she would have been. In this and all his works, he conveys his empathy with his figures' situations. Tanner was one of the first Black art students – with some of the first female art students – in America. All were welcomed by Eakins. Tanner was encouraged to become a Realist, and he worked at conveying human nature and feelings along with lifelike appearances. His imagery compels us to feel compassion for his characters, and to visualize biblical stories as they might really have happened.

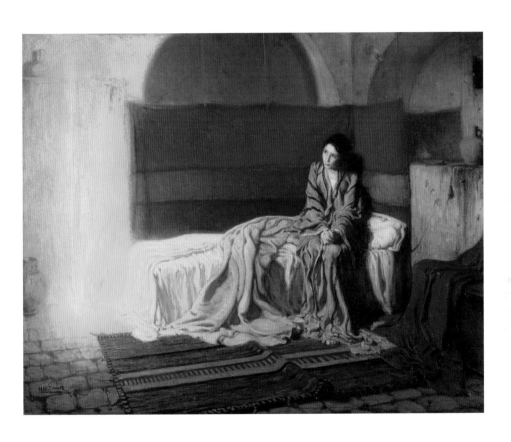

The Annunciation
1898 • oil on canvas • 144.8 x 181 cm (57 x 71¼ in.)
Philadelphia Museum of Art, Pennsylvania, USA

John Singer Sargent *'I beg you to write to me; it would be really painful for me to lose something of your friendship, which is precious to me.'*

Animated brush techniques

Born in Florence, the son of expatriate Americans, John Singer Sargent (1856–1925) did not visit America until he was twenty, but spent his childhood with his family living in various European countries. His education included learning to speak French, Italian and German, play the piano, dance and draw. At eighteen he began studying with the celebrated French portraitist Carolus-Duran (1837–1917), while also attending the Ecole des Beaux-Arts in Paris. Carolus-Duran taught him the animated brush techniques of the Spanish artist Diego Velázquez. Sargent was influenced by Impressionism, and he became the leading portrait painter of his time, also admired for his landscapes, watercolours and murals in several public buildings in the United States. He travelled widely and had many wealthy and influential friends.

Shocking attack

Sargent had travelled to the Western Front in July 1918 and was asked by the British government to commemorate the war. However, rather than painting a battle scene, he depicted the shocking aftermath of a mustard-gas attack. Helped by two medical orderlies, a line of wounded soldiers lean on each other and stumble towards a dressing station. Their eyes are bandaged from the blinding effects of the gas and one of the men turns away to vomit. In the distance, a similar line of wounded soldiers can be seen, as well as a group of uninjured men playing football. Planes fight in the sky above, and in the foreground, more injured men are almost piled on top of one another.

Feeling alive

It is hard not to be moved by the pitiful sight of the young soldiers. Used by the Germans from 1917, mustard gas caused blisters, burns, bleeding, coughing, diarrhoea, vomiting and fever. Eyes itched and temporary blindness occurred. Some men died immediately, others months later. Here, Sargent exposes the reality of war and the horrific impact of chemical weapons, but also the way the men helped one another. They are helpless and broken, and the artist sought to elicit a strong emotional response from his viewers. It is a powerful, shocking image, and through the way it provokes empathy – indeed, a sense of shock – it can remind us to be more aware of others, more appreciative of our own lives and situations, and better at realizing the consequences of our actions.

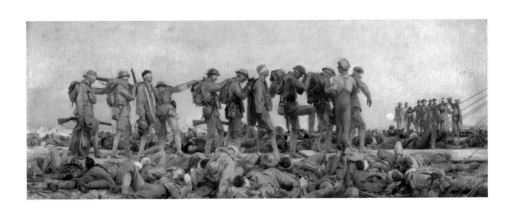

Gassed
1919 • oil on canvas • 231 x 611 cm (91 x 240½ in.) • Imperial War Museum, London, UK

Kara Walker *'I wanted to make work where the viewer wouldn't walk away.'*

Exploring social issues

Kara Walker (b. 1969) rose to fame with her large works of art, especially her black paper silhouettes that explore gender, race and Black history. An American artist and professor, Walker followed in the footsteps of her father, also an artist and professor. She grew up in California and moved to Atlanta when she was young, later studying at Atlanta College of Art and at Rhode Island School of Design in Providence. She soon began addressing the history of American slavery in her art through disconcerting imagery, using a wide range of media, including cut paper, gouache, watercolour, video animation, shadow puppets, projections and monumental sculptural installations. She often features shocking imagery of racial stereotypes to highlight problems and grab the viewer's attention.

Silhouette

Walker's large black-and-white silhouette spreads over a wall, highlighting the cruelty and horror of the American Civil War (1861–65). Figures brandish swords, flags, limbs and whips. Overall, using satire and stereotypes, the dramatic image confronts the history of racism and violence in America. Among the figures are General Robert E. Lee, and a Black woman standing on a pile of amputated limbs holding a fried chicken leg and a tattered flag; a blindfolded woman, who may be an allegorical figure of justice, coaxes a mule with a carrot. Riding the mule is the Reverend Martin Luther King Jr, the civil rights leader from Atlanta, while a Civil War soldier plants a flag, or stabs a young woman on the ground.

Compassion and understanding

In all her art, Walker tackles powerful subjects, aiming both to inspire and to unsettle her viewers . She addresses the persistence of prejudice and discrimination, as she defines her own heritage, rather than simply accepting it. Her art dismantles many romanticized ideas about the past, exposing reality and challenging predominant narratives in American history in particular. Provocative and emotional, she shocks her viewers out of complacency, forcing reassessment of past events and human feelings. When art provokes its viewers in this way, it is capable of making them see the world in a new light; it might spur them to seek out more information, or to become more socially engaged. Delivered to an audience artistically, historical facts – in this instance, about the American Civil War – arouse compassion and an emotional understanding that might otherwise have been repressed.

The Jubilant Martyrs of Obsolescence and Ruin
2015 • cut paper on wall • 420 x 1775 cm (165⅜ x 698¾ in.) • High Museum of Art, Atlanta, USA

Elizabeth Catlett *'The artist must be an integral part of the totality of Black people.'*

Race and feminism

An African-American artist who explored themes relating to race and feminism through sculpture, paintings and prints, Elizabeth Catlett (1915–2012) focused particularly on the struggles of Black people in the United States during the twentieth century. Her art amalgamates modernism, Primitivism and Cubism. Born in Washington, DC, Catlett was awarded a scholarship to the Carnegie Institute of Technology in Pittsburgh. The offer was withdrawn, however, because of her race, so she studied at Howard University in Washington, and at the University of Iowa under the Regionalist artist Grant Wood (1891–1942). In the 1940s she worked in Mexico on a fellowship, and, inspired by Diego Rivera, began producing images of adversity endured by African-American women. From 1975 she lived and worked in both Mexico and New York.

Spirited and dignified

In 1946 Catlett moved to Mexico, escaping the Jim Crow laws in the United States. She took a job at Mexico City's influential and progressive printmaking collective, Taller de Gráfica Popular. Growing up, she had spent summers with her poor grandparents in North Carolina, where she saw others living and working in extreme poverty. She began creating images of spirited, dignified Black women, blending social realism with influences from African and Mexican artistic traditions to portray social messages about the experiences of many African Americans. After the American Civil War, many former African-American slaves became sharecroppers, farming rented land and earning a share of the crop. Rather than benefiting them, however, the system provided only a tiny income and trapped many in a cycle of poverty.

Defying adversity

While the inequalities that Catlett's work addresses persist in many ways, her belief in the power of art to effect change and reform never faltered. She portrayed the elegant, working-class Black woman shown here in the hope of breaking down boundaries between races, genders and classes. She consciously sought to arouse the viewer's empathy, but never pity. Pride is an important aspect of her life and work. This linocut and her other works conjure up a sense of respect; the woman is anonymous, but represents every sharecropper, conveying great respectability in defiance of adversity, evoking the viewer's understanding, compassion and sense of motivation, especially among women and Black people. Throughout her life Catlett remained tireless in her efforts to support human rights movements.

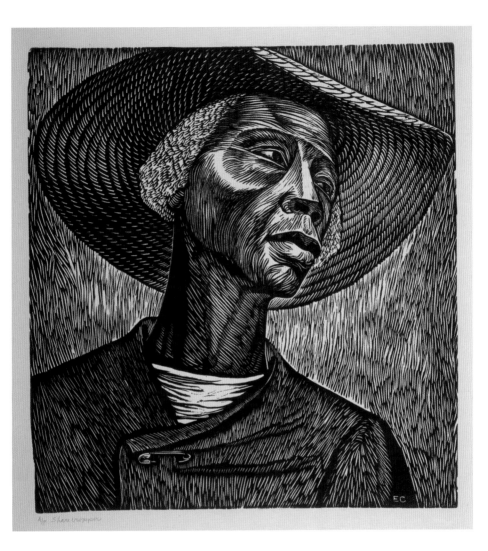

Sharecropper
1952 • linocut • 56.2 x 48.3 cm (22⅛ x 19 in.)
Philadelphia Museum of Art, Pennsylvania, USA

Learning Empathy

Amrita Sher-Gil *'These little compositions are the expression of my happiness and that is why perhaps I am particularly fond of them.'*

Western and Eastern influences

Of Hungarian-Indian descent, Amrita Sher-Gil (1913–1941) was born in Budapest. At nine years old, she moved with her family to Shimla, India, and two years later her mother took her to Florence to study with an Italian sculptor. When she was sixteen she began studying painting in Paris, first at the Académie de la Grande Chaumière and later at the Ecole des Beaux-Arts (1930–34). She became influenced by Paul Cézanne (1839–1906) and Paul Gauguin, as well as by the wall paintings of western India. She won accolades in Paris, including a gold medal, and she was the youngest person and the only Asian ever to be made an Associate of the Grand Salon. In her early twenties she returned to India, but at just twenty-eight died suddenly and unexpectedly.

Facing their fates

This painting was the first to be produced by Sher-Gil after her return to India from Paris, and it won her a gold medal from the Bombay Art Society. Sher-Gil synthesized European and Indian art traditions in her work, and when she reached India, she observed life around her with compassion, especially the people. Three colourfully dressed young women, on the cusp of adulthood and marriage, contemplate their destinies. Their situations in life mean that they had no choice about their futures. She

wrote, 'I realized my real artistic mission, to interpret the life of Indians and particularly the poor Indians pictorially; to paint those silent images of infinite submission and patience to reproduce on canvas the impression those sad eyes created on me.' With the absence of background detail, the girls' situation is made clear through their facial expressions and body language.

Deepening understanding

In depicting the conventions of Indian society, Sher-Gil shows a deep engagement with her subjects, and compassion for the disadvantaged. Her paintings are powerful representations of the human condition, and she articulates some of the particular hardships of the lives of Indian people. Although she came from a privileged background, she related to those who had to conform to often difficult social norms. The pensive expressions of these girls evoke empathy, but can also make uncomfortable viewing. Sher-Gil, a young, female artist, had enjoyed different opportunities from those she portrays; by depicting the lives of these women, she encourages an understanding of the complexity of other people's experience in her viewers. Art of this kind can push viewers to move outside their own experience, to be slower to judge and more tolerant of those whose lives are different from their own.

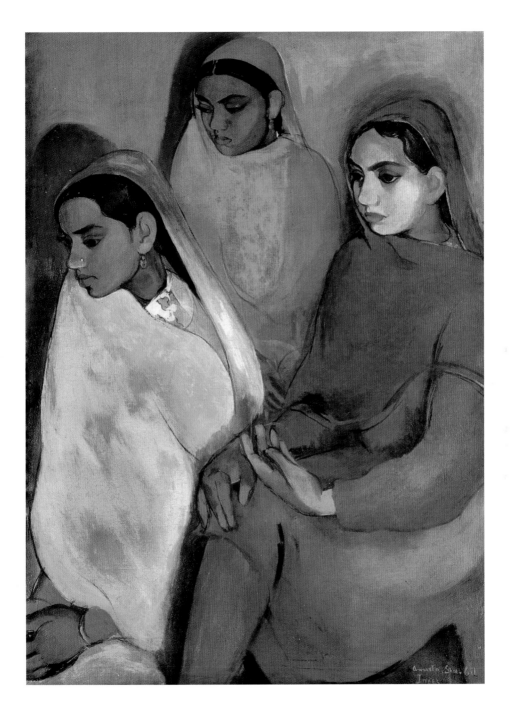

Group of Three Girls
1935 • oil on canvas • 92.8 x 66.5 cm (36⅓ x 26¼ in.)
National Gallery of Modern Art, New Delhi, India

Mary Cassatt *'I have touched with a sense of art some people – they felt the love and the life.'*

American Impressionist

As a child, Pittsburgh-born Mary Cassatt (1844–1926) lived with her family in France and Germany. At sixteen she studied at the Pennsylvania Academy of Fine Arts, then moved to Paris and trained with Jean-Léon Gérôme (1824–1904), remaining in Paris for most of the rest of her life. In the early 1870s she travelled around Europe and became inspired by European traditions of art, especially Impressionism and the influence of Japanese art. Working in a variety of media, she exhibited at the prestigious Paris Salon, then Edgar Degas invited her to exhibit with the Impressionists. She became the only American artist to do so, and promoted Impressionism in America. In 1904, in recognition of her art, the French government made her a Knight of the Legion of Honour.

Mother and child

A woman and a naked child look at the child's face reflected in a small circular mirror. The larger mirror behind them creates images within images. In 1867 two Suffragists in Kansas wore sunflower badges when campaigning for the right to vote, and from that time the colour yellow was often used to symbolize the suffrage movement. The sunflower is also the state flower of Kansas. Here, the mother and child are close both physically and mentally, with their skin tones created from the same palette, emphasizing their intimate relationship. Ultimately, the restricted palette and unusually angled composition derive from Japanese art, while the looseness of the paint application evolves from Cassatt's involvement with Impressionism.

Einfühlung

Cassatt loved painting mothers and their children. Determined to avoid sentimentality, she used family and friends as models to attain a lack of self-consciousness. Echoing the Christian tradition of Madonna and Child, and the power of a mother's feeling for her offspring, this image embodies tenderness. Four years after Cassatt painted this work, the British psychologist Edward Titchener (1867–1927) introduced the word 'empathy' as the translation of the German term *Einfühlung* (feeling into). *Einfühlung* had been coined in 1873 by the German philosopher Robert Vischer (1847–1933) in his exploration of the human capacity to see or read a work of art or literature and feel the emotions that the writer or artist describes. Cassatt's depiction of the intense connection between mother and child is a beautiful example of this dynamic at work, and the colours give the painting a warmth that heightens its emotional tenor.

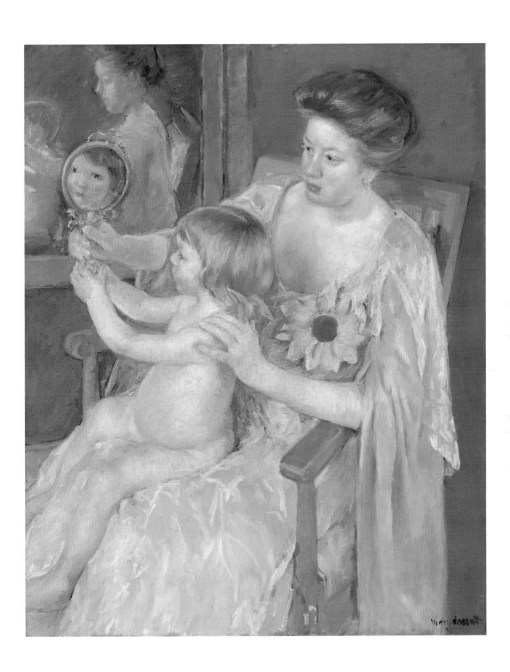

Woman with a Sunflower
c. 1905 • oil on canvas • 92.1 x 73.7 cm (36¼ x 29 in.)
National Gallery of Art, Washington, DC, USA

Gaining Inspiration

When Paul Klee wrote, 'Art does not reproduce what is visible; it makes things visible,' he was describing art's ability to inspire viewers. Similarly, people sometimes describe the experience of 'losing themselves' in a work of art, their minds transported from the present tangible time and place into their own imaginations.

Art can arouse memories, connections, recollections, or such things as curiosity, wonder, fear or happiness. It can stimulate questions, observations and insights, or inspire action for a cause or a personal issue. Visual stimuli can be exceptionally powerful, and art can draw the mind in directions that it may not have considered, posing concepts from new angles, opening perspectives or triggering associations. The artists considered in this chapter include Jan van Eyck, Joaquín Sorolla, Henri Rousseau, Andy Warhol, Paula Rego and Lubaina Himid. Each of their works discussed here has the ability to inspire in different ways, from showing imaginary or real places, to stimulating recollections or encouraging the viewer to think again about how they view and respond to the world. These artists and others invite their audience to enter the different realms of their creation, and – if we allow them – have the potential to inspire us all.

The Ghent Altarpiece (detail) by Jan van Eyck; see page 131.

Henri Rousseau *'Nothing makes me so happy as to observe nature and to paint what I see.'*

Untutored and unsophisticated

An untutored 'Sunday painter', Henri Rousseau (1844–1910) was ridiculed about his art during his life, yet he inspired artists such as Picasso and Wassily Kandinsky, who admired his naive painting style. He grew up in northwestern France in a family that was constantly plagued with financial difficulties. After spending four years in the French army, he worked in Paris, checking goods for the customs authority, which gained him the nickname 'Le Douanier'. During that time, at the age of forty, he began drawing and painting. He initially obtained a licence to copy paintings at the Louvre, and by the age of forty-nine he had become a full-time artist. Although he admired other artists with highly realistic styles, his technique was untrained and unsophisticated.

Bared teeth in the long grass

This is Rousseau's first jungle painting, and he went on to paint about twenty on a similar theme. A large-eyed tiger with bared teeth crouches in long grass. Around it are bending trees, driving rain and an ominously dark sky. Despite Rousseau's claim of painting the exotic image from direct experience, he never left France, and instead used references from library books and the Jardin des Plantes in Paris. The plants are copied from both tropical and house plants, and, with its incorrect proportions and odd features, the

tiger was probably based on stuffed animals in the zoology galleries of the Jardin des Plantes. Rousseau said later that the tiger was stalking a group of unseen explorers.

Untroubled youth

When it was first exhibited at the Salon des Indépendants in Paris in 1891, this painting attracted derision from several critics for its peculiarities, including the strange-looking tiger and vegetation, and the childlike stripes of rain. In addition to the sources we have already mentioned, Rousseau probably gained inspiration from Japanese woodblock prints and the paintings of Eugène Delacroix (1798–1863). Yet while many scoffed, a number of avant-garde artists hailed Rousseau's work as naive art, and its pioneering, unsophisticated technique inspired new approaches. His lack of conventional representation was later celebrated and embraced by the Surrealists, many of whom created fantastic, dreamlike imagery that echoes his approach. Rousseau's art connects to the young, carefree part of the self that adults can often forget. It enables them to leap into the imagination of their innocent earlier selves, to see the world once more with fresh eyes, untainted by worry or disappointment.

Surprised! Tiger in a Tropical Storm
1891 • oil on canvas • 130 x 162 cm (51⅛ x 63¾ in.) • The National Gallery, London, UK

Joaquín Sorolla *'At such moments I am unconscious of materials, of style, of rules, of everything that intervenes between my perception and the object or idea perceived.'*

Sunny coastal scenes

Joaquín Sorolla (1863–1923) was raised by relatives in Valencia after his parents died in a cholera epidemic. He began studying art at the age of fifteen and later gained a scholarship to study at the Spanish Academy in Rome. Back in Spain, his Impressionistic painting style became extremely popular, and in 1900 he was made Knight of the Legion of Honour and awarded a medal at the Paris Universal Exposition. He was also given memberships to the Fine Art Academies of Paris, Lisbon, Valencia and Madrid, and in 1909 he had a solo exhibition at New York City's Hispanic Society, which attracted a commission to paint the president. On his return to Valencia he bought a beach house, and for the rest of his life he drew inspiration from the Mediterranean coast.

Sea and rock

As with many of Sorolla's paintings, this was produced outdoors with a high viewpoint, and yet, unlike many, it contains no underlying narrative, which was one of the contrasts between his work and French Impressionism. With impasto paint and vigorous brushwork, Sorolla indicates a transient moment, focusing on light reflecting on the bodies and the water, and shadows on the sand, restricting his palette to whites and blues. It is painted at his favourite El Cabañal beach in Valencia; the horizon is high, with little sky to be seen, and he has partially cropped the horse and boats, showing the influence of photography. Most of the painting consists of the sparkling blue sea, the horse and the boy, and the entire scene is bathed in sunlight.

Identity and belonging

Known as the 'master of light', Sorolla was especially inspired by the coast of Valencia, and the work of Velázquez and the French Impressionists. He reflected, 'I hate darkness. Claude Monet once said that painting in general did not have light enough in it. I agree with him. We painters, however, can never reproduce sunlight as it really is. I can only approach the truth of it.' He painted coastal scenes almost unceasingly, capturing the effects of the dazzling Mediterranean sunlight. He evokes what many people feel about special places that inspire them personally, described as 'topophilia' by the poet W. H. Auden (1907–1973): the notion that certain places can become mixed with one's sense of identity and belonging. Having a sense of belonging is fundamental, and its importance cannot be separated from physical and mental health. Feeling that one has support and is not alone usually leads one to cope more effectively, reducing the physical and mental impact of negative situations.

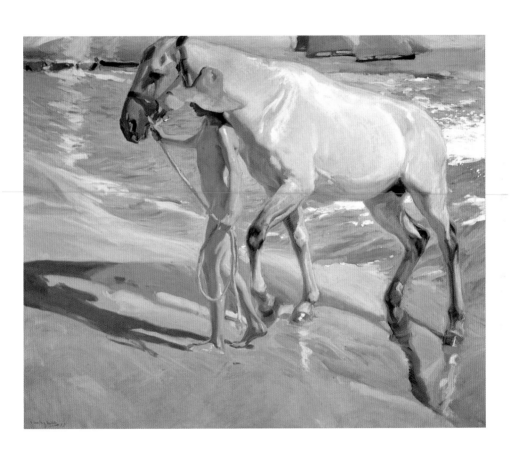

The Horse's Bath
1909 • oil on canvas • 205 x 250 cm (80¾ x 98½ in.) • Museo Sorolla, Madrid, Spain

Jan van Eyck '*ALC IXH XAN (I do as I can).*'

Painter family

One of the leading painters of the Northern Renaissance, Jan van Eyck (before 1395–1441) became a master of the new technique of oil painting, and one of the first Northern artists to be known by name. He became admired for his highly realistic painting style, but little is known about his life. Born in Flanders (Belgium), he probably had a sister and two brothers, including Hubert van Eyck (*c*. 1385/90–1426); all were possibly painters. He ran a busy workshop in Bruges, and from about 1422 he worked at court, first for John of Bavaria and then for Philip the Good, Duke of Burgundy. It is likely that he was a member of the nobility, and he was literate; he signed his paintings, which was unusual for the time.

The end of the world

Also known as *The Adoration of the Mystic Lamb*, this is a huge polyptych – a painting in several sections – consisting of twenty-four separate panels with twelve always on view. Its main theme is human redemption through Christ's sacrifice. When the panel is open, God can be seen with the Virgin Mary, John the Baptist and singing angels. It is generally accepted that after Hubert's early death, most of the altarpiece was painted by Jan. Essentially, it is a fantasy about what might happen at the end of the world, as described in the Book of Revelation. Although Van Eyck did not invent oil painting, he developed things that could be done with it, including painting details of almost unprecedented veracity.

Musical motivation

Moving away from the rigidity of Byzantine, International Gothic and medieval art, Van Eyck created the illusion of depth and light, and conveyed astonishing realism and symbolism. His innovations inspired generations, revolutionizing the art world and making oil paint one of the most popular art materials. The Ghent altarpiece also continues to inspire musical interpretations. Within it, music is conveyed through angels singing and playing instruments, portraying the medieval belief that heaven is filled with divine music. Although it is not clear what the music is, judging by the facial expressions of the angels and choir, and the positions of their mouths, it is something specific, and this has inspired musical interpretations for centuries. Whether we listen to, play or imagine it as we can here, music can be inspirational. Use your imagination to 'hear' the music in this painting; it will give you an instant uplift.

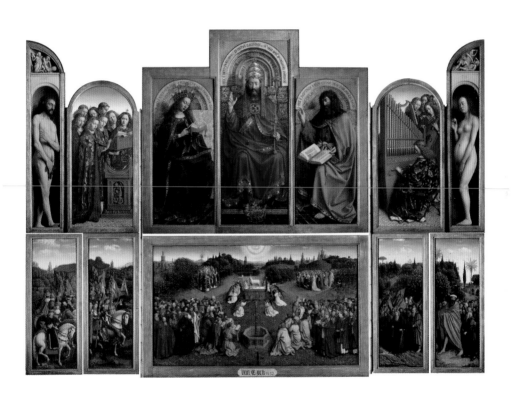

The Ghent Altarpiece
1432 • oil on panel • 350 x 461 cm (137¾ x 181½ in.) • St Bavo's Cathedral, Ghent, Belgium

Andy Warhol *'Don't think about making art, just get it done. Let everyone else decide if it's good or bad...while they are deciding, make even more art.'*

Blurring distinctions

Although he was often ill as a child and regularly absent from school, Andy Warhol (1928–1987) became internationally recognized as one of the most important Pop artists, challenging basic assumptions of what art is. Warhol was born in Pennsylvania to Czechoslovakian parents, studied pictorial design at the Carnegie Institute of Technology in Pittsburgh from 1945 to 1949, then moved to New York City, where he became a highly successful commercial artist. In 1960 he began creating images of consumer goods on canvas, using both fine-art and commercial techniques, including painting and screenprinting. From his huge silver-painted studio that he called The Factory, he expanded into performance art, photography, film-making and sculpture, always exploring consumerism and the media.

Everyday product

Made up of simple shapes, this painting deliberately resembles supermarket shelves. Using his experience as the most successful and highly paid commercial illustrator in New York, Warhol made consumer goods and popular culture his central theme. Campbell's soup was an everyday product that he depicted regularly because, he said, he ate it every day for twenty years, and because anyone, rich or poor, could buy it and it was the same for all. After using

stencils, he hand-painted much of this image. Although it looks precise, on closer inspection inconsistencies can be seen, a fact that draws a distinction between commercial and fine art. The year he painted this, Warhol began screenprinting, the first time the technique had been used in fine art.

Ordinary to extraordinary

Many of Warhol's ideas have been inspirational. He reinvented the concept of artistic expression using ideas from popular culture, which inspired painters, fashion designers, photographers, musicians and film-makers. His focus on mass-produced commercial goods eroded boundaries between 'high' and 'low' culture, while his statement 'In the future, everyone will be famous for fifteen minutes' and his techniques in social networking and manipulation of the press inspired millions long before reality television and social media. Because his art is accessible to all, it continues to inspire many. Through the representation of everyday objects, a message is sent to the viewer that ordinary, unremarkable things can be extraordinary. If anyone is feeling in need of inspiration, this painting shows that anything is possible, as long as they are open to new ideas and ways of thinking.

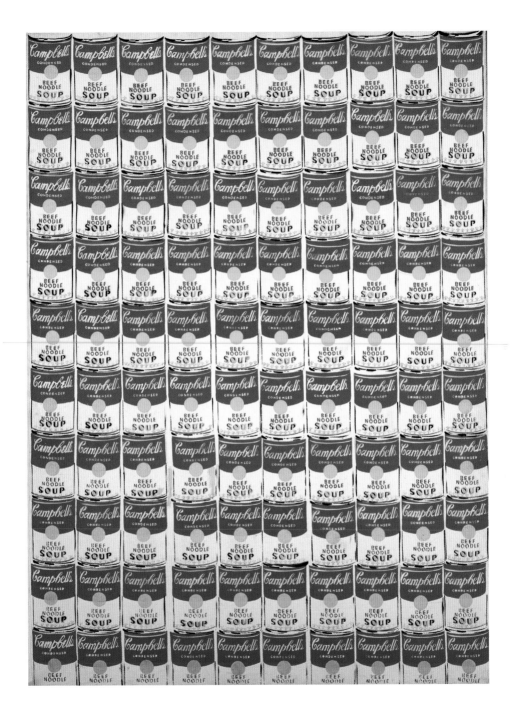

100 Cans
1962 • casein, spray paint and pencil on cotton • 182.9 x 132 cm (72 x 52 in.)
Albright-Knox Art Gallery, New York, USA

Paula Rego *'I get inspiration from things that have nothing to do with painting.'*

Telling stories

Paula Rego (b. 1935) has lived mainly in London since leaving her native Lisbon as a young woman. When she was sixteen she was sent to an English finishing school, and a year later she transferred to the Slade School of Art in London. There she met Victor Willing (1928–1988), a fellow art student, and they later married. While spending time in both Portugal and England, Rego began exhibiting, first with the well-established London Group, and then internationally. In 1966 a solo exhibition of her work was held in Lisbon and London, and in 1990 she became the first artist in residence at the National Gallery, London. Throughout her career, Rego has sought new ways of telling stories, often addressing unsettling emotional experiences and highlighting the plight or situations of others.

Reminiscences

One of Rego's most complex works, this large composition is filled with symbols, signs and stories. An elderly sailor sits in his home, surrounded by reminders of his past, and by indications of the future through his grandchildren. So, as they sit in the present, with the past and future around them, the painting conveys time. The past now exists only in the seaman's head and in inanimate objects; the present is him, his wife (who is at the back, by the door) and their three grandchildren; and the future is going to be experienced by those children as they grow. Yet while this may at first be perceived as an image of nostalgia, there is also something unsettling. The little girl in the background is set against an empty landscape.

Reflecting on the past to improve the future

Since she began working as an artist, Rego has produced art that reacts to injustice. In the 1960s she created bold art that parodied and denounced the brutality of the Portuguese dictatorship (1933–74), and she has continued in this approach to her varied subject matter. Here, the barren view out of the door suggests national loss. After the revolution of 1974, Portugal underwent a period of economic collapse and social instability. Even during the 1990s, despite restored democracy and political freedom, difficulties remained, represented here with the contemplation of past and present – and the room without a view. Even the girl at the table writes on a blank sheet of paper. Rego's work deliberately provokes viewers and inspires them to respond to the subjects she addresses, or simply to reflect.

Time – Past and Present
1990 • acrylic on paper on canvas • 183 x 183 cm (72 x 72 in.)
Fundação Calouste Gulbenkian, Lisbon, Portugal

Lubaina Himid *'I'm a painter and a cultural activist.'*

Himid's disclosures

Although she was born in Zanzibar, Lubaina Himid (b. 1954) moved to the United Kingdom with her mother when she was a baby. Now a British artist, curator and professor of contemporary art at the University of Central Lancashire, Preston, her art addresses aspects of identity, culture and history. As a student, Himid studied theatre design at Wimbledon College of Art, and then received an MA in cultural history from the Royal College of Art in London. One of the first artists involved in the UK's Black Arts Movement in the 1980s, she was awarded an MBE for 'services to Black Women's art' in 2010. In 2017 she won the Turner Prize, and in 2018 she was made a CBE.

Giving a voice

Himid creates paintings, drawings, prints and installations. Her work addresses her heritage and 'the contribution Black people have made to cultural life in Europe for the past several hundred years'. Focusing on the lack of representation of Black and Asian women in the art world, *Naming the Money* is an installation composed of 100 painted, life-sized figure cut-outs on detached, shaped cardboard so that viewers can walk around them. The figures represent African slaves in the royal courts of eighteenth-century Europe, who worked as ceramicists, herbalists, toymakers, dog trainers, shoemakers, cartographers and painters. The figures are dressed as courtiers, and a soundtrack gives each a voice and an identity that were taken away from them when they were enslaved.

Rousing reconsiderations

As part of the Black Arts Movement in the 1980s, whereby several Black British artists tried to create opportunities and encourage other Black artists to show their work, Himid began exploring and exposing the strength of Black people throughout history, and the way their lives have so often been marginalized, suppressed and silenced. Through this artwork and others, Himid reminds viewers of shocking aspects of Black history, arousing ideas and more positive action for the future in her work as well as her art-world activities. By giving her figures names and voices, she restores their individual humanity, inspiring a personal, empathetic connection between viewer and artwork.

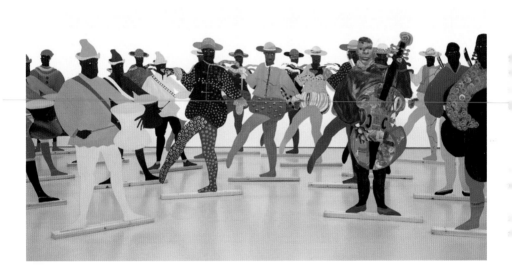

Naming the Money
2004 • installation, 100 life-sized painted cut-out figures on board
Installation view, *Navigation Charts*, Spike Island, Bristol, UK

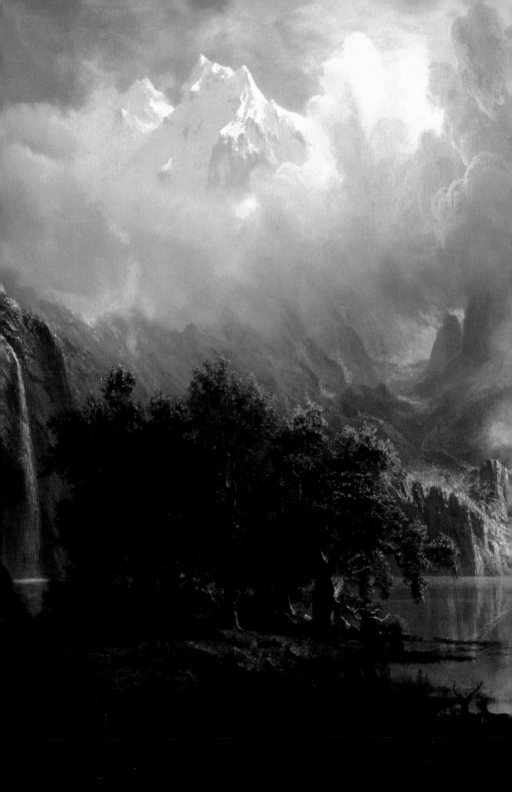

Creating Energy

Learning something new, picking up new ideas or gaining enjoyment from a work of art can stimulate inner energy, or the art itself can project a sense of vigour. In some workplaces, art has been shown to boost productivity. Through his research group Identity Realization (IDR), Dr Craig Knight, honorary research fellow at the University of Exeter, has studied the psychology of working environments. He discovered that when working areas are enriched with art, employees work better, and with more dynamism. In the studies conducted by Knight and his team, office workers who were in environments featuring art and plants worked far more speedily and had fewer health complaints than those in unadorned offices.

Many works of art, for example sculptures, sketches and paintings, seem to exude the energy the artists used in making them. In this chapter, artists including Piet Mondrian, Edgar Degas, Albert Bierstadt, Hokusai and Marc Chagall are all considered in the light of some of their work communicating or activating mental, emotional or physical energy.

Rocky Mountain Landscape (detail) by Albert Bierstadt; see page 143.

Creating Energy

Edgar Degas *'People call me the painter of dancers, but I really wish to capture movement itself.'*

Light and movement

Although Edgar Degas (1834–1917) became known as an Impressionist, he rejected the label, preferring to call himself an 'Independent'. He was intrigued by the depiction of light, movement and figures, and produced paintings, pastels, drawings, photographs, prints and sculpture. Born in Paris, he had a good education, and to please his father he initially enrolled at law school, but after two years he changed to study art at the prestigious Ecole des Beaux-Arts. He spent three years in Italy, and in 1870, on the outbreak of the Franco-Prussian War, he joined the National Guard. Even though his artistic approach differed from that of the Impressionists, he helped to organize their first exhibitions. His education was classical, but his art was modern, particularly influenced by photography.

Sense of immediacy

More than half of Degas's works depict dancers. This painting features several young ballerinas and their mothers in a dance studio. Some are sitting, some stand, and the girl in the centre performs for the teacher, Jules Perrot (1810–1892), who was famed throughout Europe. In the background the mothers gather, while in the left foreground a music stand holds sheet music. A large mirror on the wall reflects part of the room. Some of the girls have their backs to the viewer;

others are chatting to each other or otherwise preoccupied. The painting creates the impression that the viewer has stepped into the room. Immediacy is conveyed through elements of the painting being cut off at the edges – an idea taken from photography.

Diagonal appeal

Degas moved away from his classical education as he built on artistic influences such as Japanese *ukiyo-e* (pictures of the floating world), the work of Eugène Delacroix and photography. The first two influences convey dynamism through composition, while Delacroix also encouraged the expressive application of paint. Degas assimilated these ideas and used them to depict human figures enlivened by dance. His dancers are portrayed in informal, often unflattering poses, as though caught in a snapshot. They stretch, bend, adjust their clothing, relax. Although most are not dancing, energy fills the room. Overall, the sense of motion, of changing positions, animated conversation and readiness to spring into action is apparent. Dance itself has both physical and psychological benefits. It is a great way to exercise and to take the mind off problems.

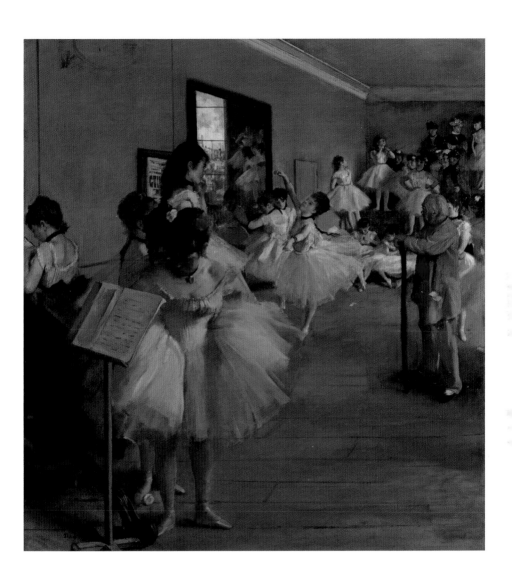

The Dance Class
1874 • oil on canvas • 83.5 x 77.2 cm (32⅞ x 30⅜ in.)
The Metropolitan Museum of Art, New York, USA

Albert Bierstadt *'Truly all is remarkable and a wellspring of amazement and wonder.'*

Hudson River School

Albert Bierstadt (1830–1902) was born in Prussia, but grew up in Massachusetts. He later returned to Europe to study painting in Düsseldorf, and while there went on sketching tours of Germany, Switzerland and Italy. On his return to America, he lived again in Massachusetts before moving to New York and becoming part of the Hudson River School, an informal group of artists who painted outdoors along the Hudson River. He also travelled to the Rocky Mountains and to various other places in the United States and Europe. He later used his *plein-air* studies to create atmospheric paintings of the landscape, employing the skills he had developed in Europe, including bold contrasts of light. These paintings established him as one of the most respected painters of the American West.

Leading the eye

Bierstadt painted this landscape seven years after making studies of the Rockies in 1863. The huge canvas was one of several he produced at the time, and they confirmed his reputation. Drama is conveyed with darkened areas at the side and in the foreground, areas of deep shadow that contrast directly with highlights in the background and sky. The forms of the mountains are echoed by banks of cloud that appear to move across the sky, while a sparkling waterfall cascades into the still water of the lake that mirrors the scene. Almost lost in the foreground shadows and vegetation is a family of deer. Having learned from photographic techniques, Bierstadt skilfully leads the viewer's eye into and around the landscape.

Drawn by light

Famous for his large-scale, dramatic paintings of the American West, Bierstadt became linked with an art movement called Luminism. He was not aware of the term himself, since it was not used until the mid-twentieth century, so he could not be said to have adhered to a specific style. However, the name describes painters of the American landscape who worked from about 1830 to 1870, making paintings that are characterized by dramatic portrayals of light. This sweeping scene carries the viewer on an exhilarating journey into a lavish landscape. Ambitious, breathtaking scenes such as this can remind us of the great outdoors, which we know can energize us. Studies have shown that even a short period in the open air increases the flow of oxygen to the brain, resulting in greater energy and alertness, and decreasing drowsiness.

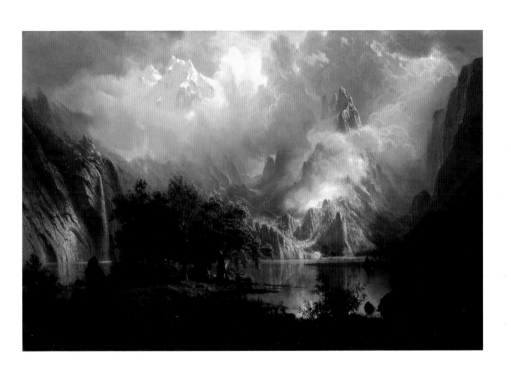

Rocky Mountain Landscape
1870 • oil painting • 93 x 139.1 cm (36⅝ x 54¾ in.) • The White House, Washington, DC, USA

Piet Mondrian '*The artist makes things move,* and is moved.... *He who makes things move also creates rest.*'

Drawn by light

An innovator of abstract art and a founder of the Dutch art movement De Stijl, Piet Mondrian (1872–1944) began his career painting landscapes, then developed an interest in the principles of theosophy and began to simplify his paintings radically. Born in the Netherlands, Mondrian studied painting in Amsterdam. In Paris from 1911 he experimented with a form of Cubism, and during World War I he returned to the Netherlands. There, in 1917, with Theo van Doesburg (1883–1931) and others, he produced a magazine called *De Stijl* (The Style) in which he wrote about his theories. Back in France in 1919, he developed Neo-Plasticism, creating grid-like paintings with a drastically reduced palette. For two years around the outbreak of World War II he lived in England, then he settled in New York in 1940.

Jazz and dancing

From the moment Mondrian arrived in New York City, he fell in love with it. Fascinated by the architecture and the buzz of activity everywhere, he also loved the boogie-woogie music he heard on his first evening there. Boogie-woogie had developed in African-American communities during the 1870s. By the late 1920s it was a popular and widespread musical genre played in many venues and accompanied by a particular kind of dancing. Formed of squares, straight lines, right angles, primary colours and white, this painting represents the cars, people and buildings on the streets, as well as the syncopated rhythm of boogie-woogie.

Pulsating dynamism

To uncover the mystical energy of the universe, Mondrian reduced his paintings to their fundamental elements. The yellow squares here were inspired by New York's yellow cabs, and the grid represents the flow of traffic, people pounding the streets, and the tempo of boogie-woogie. Boogie-woogie dancing was usually impromptu, performed to strongly cadenced music. Couples expressed it with characteristically acrobatic movements, incorporating lively steps from the Charleston, tango and foxtrot, Mondrian's favourite dances. So this rhythmical painting expresses the life, colour and pulsating dynamism that Mondrian discovered and loved. He shows here that through colour, rhythm and vibrancy, an abstract painting can imbue us all with increased vitality through the overall impression it makes, the colours, sense of rhythm and positive shapes.

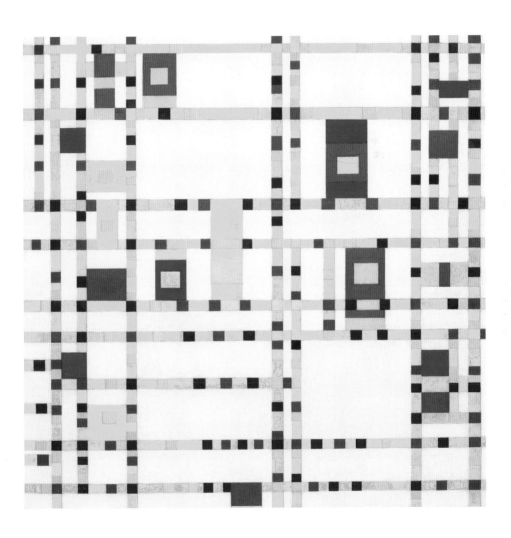

Broadway Boogie Woogie
1942–43 • oil on canvas • 127 x 127 cm (50 x 50 in.) • Museum of Modern Art, New York, USA

Katsushika Hokusai *'When I am a hundred and ten everything I do, the smallest dot, will be alive.'*

Ukiyo-e

Growing up east of Edo (present-day Tokyo), Katsushika Hokusai (1760–1849) became a painter and printmaker of the *ukiyo-e* school. By the age of six he was displaying great artistic talent. After working in a bookshop and library, he became apprenticed to a woodblock carver and then joined the studio of the leading *ukiyo-e* artist Katsukawa Shunshō (1726–1793). Japanese artists regularly changed their names, but Hokusai did this more than most, and during his career he went by more than thirty names. His early works include paintings and prints of landscapes and actors. He also produced simplified drawing manuals called *manga* (meaning random drawings) that were an immediate success, and he created his most famous print series, *Thirty-six Views of Mount Fuji*, between 1826 and 1833.

Mount Fuji

Part of that series, this print demonstrates Hokusai's rich imagination and skill. Despite the difficulties of going against convention, he changed Japanese art, moving away from traditional *ukiyo-e* images of courtesans and actors. Instead, his work focused on landscapes and images of daily life, and this example of flowing lines, a reduced palette of striking colours, dramatic composition and a reinterpretation of nature inspired many. Snow-capped Mount Fuji – which is

sacred in Japan – is minimized behind the huge, curving wave that threatens to engulf three fishing boats. Rowing the boats are twenty-two men, their minute proportions indicating the scale of the wave. Storm clouds gather, and the dark sky around Fuji suggests that it is early morning.

Dealing with life events

Probably the most famous image in Japanese art, Hokusai's 'Great Wave' invigorated the Impressionists, inspired composers to write music and even has its own emoji. Radiating vitality, it has instigated many similarly energetic responses, including that of the French composer Claude Debussy (1862–1918), who wrote his 'symphonic sketches' *La Mer* in 1903–5, directly inspired by the image. In homage to Hokusai, the first edition of Debussy's music had a picture of a wave on the cover. Here, the massive wave swells high above sea level and curves, claw-like, over the fishing boats being tossed below it. In the background, Mount Fuji remains still and solid, immortal, immovable. The vision of human fragility and defencelessness is a reminder of the part humans play in nature. Looking at this print, the viewer focuses on the power of nature, which helps them to put life's tragedies in perspective, and can in turn energize.

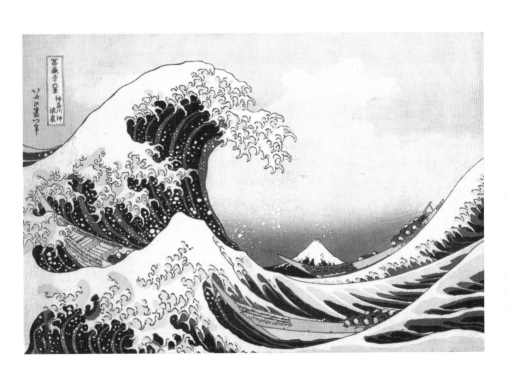

Under the Wave off Kanagawa
c. 1830–32 • woodblock print; ink and colour on paper • 25.7 x 37.9 cm (10⅛ x 15 in.)
The Metropolitan Museum of Art, New York, USA

Jacques-Louis David *'The Antique will not seduce me, it lacks animation, it does not move.'*

The Prix de Rome

Neoclassicism evolved after the ancient Roman cities of Herculaneum and Pompeii were excavated in the mid-eighteenth century, and Jacques-Louis David (1748–1825) became the leading painter of the movement. He was born in Paris and, as the outstanding student of his year at the French Academy, won the coveted Prix de Rome. He spent the years 1775–80 in Rome, and on his return became famous for his history paintings and portraits. He took an active part in the Revolution of 1789, was elected as deputy to the new parliament, and was briefly imprisoned in 1794–95. He became Napoleon Bonaparte's official court painter, and after the fall of the Republic, the new French king, Louis XVIII, granted him amnesty and asked him to be his court painter. David, however, preferred exile in Brussels.

Fiery horse

After the French Revolution, Napoleon became the most powerful man in France, proclaiming himself emperor a few years later. Commissioned by Charles IV, King of Spain, this portrait was intended to depict Napoleon's military success and to hang in the Royal Palace of Madrid. Often criticized for being exaggerated and unnatural, the painting portrays Napoleon just after he had staged a *coup d'état* against the revolutionary government and installed himself as first consul. Although Napoleon refused to sit for the work, he gave David instructions about it, saying he wanted to be shown as 'calm on a fiery horse'.

Forces of nature

David painted Napoleon on a powerful Arabian stallion, showing him as a dynamic leader, full of energy. His upward-pointing arm echoes the angle of the mountain and extends the image's diagonal emphasis, while his billowing cloak enhances the sense of movement. The strong slanted accent gives the painting its vigour, and the highest point of the cloak thrusts the eye forwards. Wind lifts the horse's mane and tail and sends the clouds scudding across the sky, the forces of nature echoing the energy of the central image. Exaggerated though it may be, the painting is undeniably stirring. In reality, Napoleon did not lead his troops through the Alps, but followed them days later, riding a donkey. David's achievement is to have created such a dynamic, energetic picture from uninspiring circumstances.

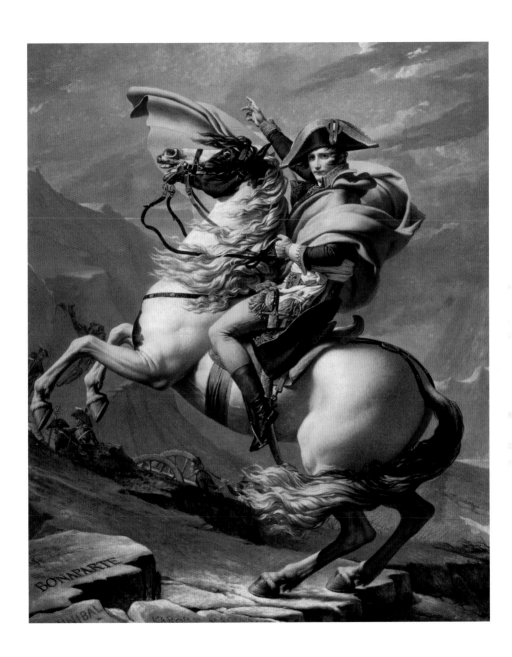

Napoleon Crossing the Alps
1801 • oil on canvas • 261 x 221 cm (102⅓ x 87 in.) • Château de Malmaison, Paris, France

Creating Energy

Marc Chagall *'Despite all the troubles of the world in my heart I have never given up on the love in which I was brought up, or on man's hope in love.'*

Chagall's inspirations

Born in Vitebsk, Belarus, part of the Russian Empire, Marc Chagall (1887–1985) studied drawing locally, and then painting in St Petersburg. In 1910 he moved to Paris, where he mixed with avant-garde artists and became influenced by art movements including Impressionism, Post-Impressionism, Fauvism and Cubism. When he returned to Belarus he created theatre scenery, then he settled in the South of France, but when World War II broke out, he escaped to New York, where he befriended Piet Mondrian and created scenery for the New York Ballet. After the war he returned to France and painted the ceiling of the Paris Opéra. He also designed stained-glass windows for cathedrals in Reims and Metz, for the United Nations building in New York, for the Art Institute of Chicago and for a synagogue in Jerusalem.

Enthusiasm for life

During the winter of 1917–18, towards the end of World War I, Chagall created three paintings, including the one opposite, that have become among his most famous. This image shows his energetic enthusiasm for life, despite the terrible things that were happening across the world. In general, life was worsening for Jewish people like him, but there was hope. In Russia in 1917 the October Revolution occurred, giving Jewish people (among others) the same rights as other citizens. Growing up in the Russian Empire, Chagall had experienced blatant discrimination. But he was blissfully happy with his wife, Bella Rosenfeld, and this painting conveys his positivity. Bella flutters in the air, held up on Chagall's arm; he wears his finest clothes and laughs. The background is his home town of Vitebsk.

Sharing the love

Chagall's dreamlike subjects came from his imagination, his personal experience and Eastern European folklore. The lively imagery conveys the exhilaration he associated with the love he felt for his wife. Here, she floats on air, as if a light wind has carried her up, while both their faces glow with happiness and adoration. They are on a walk in the country and the energy created by their powerful emotion lifts her up. Despite many hardships, Chagall nearly always remained optimistic, filling his paintings with his own verve, but never more so than when he expressed the happiness and energy that love and companionship give to us all.

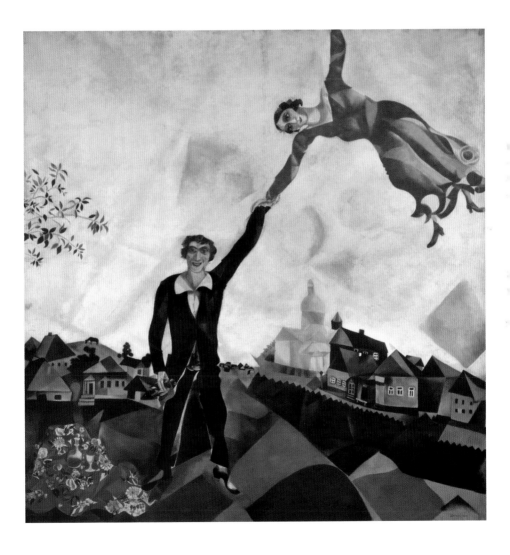

The Promenade
1917–18 • oil on canvas • 169.6 x 163.4 cm (66¾ x 64⅓ in.)
State Russian Museum, St Petersburg, Russia

Finding Hope

In 1883, distressed over an argument with his lover Camille Claudel, Auguste Rodin wrote, 'In a single instant I feel your terrible force. Atrocious madness, it's the end. I won't be able to work any more...yet I love you furiously.' For the next fifteen years Rodin and Claudel continued their volatile romance, both producing powerful sculptures, channelling their feelings of love and hope. Other artists, such as Wassily Kandinsky and Henri Matisse, used colour and fluid marks to explore and express their feelings of hope, and Augusta Savage produced compelling sculptures that exude hopefulness. Hope is an essential part of being human. Too often, we dwell on the world's problems and even more on our own personal struggles, and the art in this chapter gives us all a break from the bad news that is almost constantly being brought to our attention. In different ways, the art can be encouraging, reminding us of that more optimistic side of human nature that will help us to cope with negativity.

Colour Study; Squares with Concentric Circles (detail) by Wassily Kandinsky; see page 157.

Auguste Rodin *'The main thing is to be moved, to love, to hope, to tremble, to live.'*

Incredible naturalism

Generally considered the founder of modern sculpture, Auguste Rodin (1840–1917) created naturalistic art that broke with figurative sculpture traditions. From the age of fourteen he attended a school specializing in art and mathematics. In Italy in 1875 the work of Michelangelo had a profound effect on him. Returning to Paris, he produced *The Age of Bronze*, an incredibly lifelike, life-sized figure. Critics accused him of taking a cast of a man instead of carving it by hand, which was unacceptable at the time. After proving his innocence, he was commissioned to create huge bronze gates for a planned museum of decorative arts. He dedicated years to his monumental *Gates of Hell*, but they were never used because the museum was abandoned. Nonetheless, he re-created many of the figures on them into large, individual sculptures.

The embodiment of creativity

Originally conceived as part of the *Gates of Hell*, the figure opposite – planned for the lintel at the top – was taken from Dante's *Inferno*, and was initially conceived as Dante himself. However, he can also be seen as the epitome of every creator who works from the imagination. Some scholars suggest that it is a self-portrait of Rodin himself. Whoever he represents, he is the embodiment of the mental effort of creativity, with his head on his clenched hand, his knitted brow, compressed lips and flexed muscles. Rodin thought so highly of the work that he requested a cast of it be placed next to his tomb in Meudon, Paris, serving as his headstone and epitaph.

Contemplation

This male figure on a rock, deep in thought, balances his chin on one hand, communicating to the viewer his state of mind. Yet that state of mind is widely interpreted by viewers as anything from creative to depressed, sad or hopeful. Rodin made it to epitomize the strenuous but positive processes of a creative mind. However, some psychologists believe that the wide-ranging reactions to the work might tell viewers more about themselves than about Rodin's intentions: that they project their own thoughts and feelings on to the sculpture. Rodin created *The Thinker* as a strong, athletic figure in order to convey that the act of thinking is a powerful exercise. It portrays the idea of a man seeming to face a dilemma, and it was one of the first times in art that wisdom was represented by a realistic-looking man and not by a goddess. Overall, it suggests that clearing some time to think about problems can increase feelings of hope.

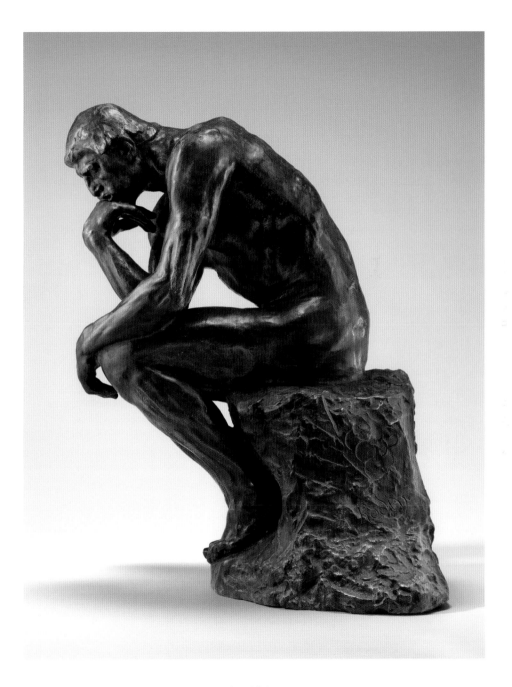

The Thinker
1880 (model); 1901 (cast) • bronze • 71.5 x 36.4 x 59.5 cm (28⅛ x 14⅜ x 23½ in.)
National Gallery of Art, Washington, DC, USA

Finding Hope

Wassily Kandinsky *'Colour transmits and translates emotion.'*

Expressing spirituality

One of the pioneers of abstract art, Wassily Kandinsky (1866–1944) was a painter, wood-engraver, lithographer, teacher and theorist. Influenced by theosophy, he sought to express spirituality through his art. Born in Moscow, Kandinsky initially studied law and economics, then studied art in Moscow and in Munich. He travelled around Europe, painting and printmaking in a style inspired by Russian folk art. On returning to Munich he painted with brighter colours, inspired by Fauvism, and in 1910 he wrote *Concerning the Spiritual in Art*, describing how he wanted his art to provoke emotion in viewers. The following year he began the expressive artists' group Der Blaue Reiter. He returned to Russia during World War I, then went back to Germany and was appointed professor at the Bauhaus.

The perception of colour

This small painting was Kandinsky's study of the perception of colour. He used it for teaching and when deciding which colours to use in his paintings. Primarily working with watercolour, he explored how pigments affect the viewer's perception. He constantly explored colour combinations to try to stimulate greater awareness and to awaken emotions. Twelve squares are filled with concentric circles, and the juxtaposition of both shapes and colours communicates a sense of harmony and vibrancy. Kandinsky had a condition called synaesthesia, which is the ability to experience more than one sense at a time, such as 'hearing' colours or 'seeing' sounds. Colour for him created the essence of life and spirituality. He wrote extensively about his ideas of colours interacting with one another and with the viewer.

'Soul vibration'

Because of his synaesthesia, one of Kandinsky's main interests was the way in which colour could reach deep into the soul or psyche, changing the outlook. He aimed to inspire internal connections in the viewer through his placement of colours and shapes. Here, the bright combination of colours and the harmonious arrangement connect with many, arousing feelings of hopefulness. Using the simplest forms, Kandinsky generates an impact on and emotional response in the viewer through these elements. According to him, all colours are able to exert a twofold effect. The first is a simple physical impact on the eyes that the viewer enjoys, giving rise to uplifting feelings; the second is more spiritual, on a deeper level, that he called 'soul vibration', when the colours create different resonances within each person individually, arousing positive feelings such as hope and aspiration.

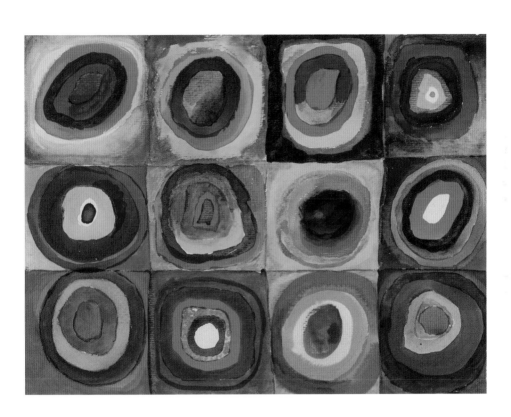

Colour Study – Squares with Concentric Circles
1913 • watercolour, gouache and crayon on paper • 23.8 x 31.4 cm (9⅓ x 12⅓ in.)
Städtische Galerie im Lenbachhaus, Munich, Germany

Augusta Savage *'He almost whipped the art out of me.'*

Savage's struggles

Florida-born Augusta Savage (1892–1962) began sculpting clay animals as a child, but her father, a Methodist minister, believed sculpture to be sinful and whipped her for it. Undaunted, she continued. In 1921 she gained a scholarship to the Cooper Union school of art in New York City, where she was selected over 142 men. Two years later she won a scholarship to study at the Fontainebleau School of Fine Arts in France, but after discovering she was Black, the French government withdrew the offer. She became associated with the Harlem Renaissance, an intellectual and cultural revival of African-American creativity, and in 1939 she was the first African-American woman to open her own art gallery in America. Since she could afford to cast only in clay or plaster, much of her work is lost.

Homage to a Black anthem

In this bronze twelve singers represent harp strings, with God's hand and arm forming the sounding board and a kneeling man holding music symbolizing the foot pedal. Savage made the work on commission for the New York World's Fair in 1939, calling it *Lift Every Voice and Sing* after a national Black anthem by the brothers James Weldon Johnson and John Rosamond Johnson, but officials changed it to *The Harp*. At the fair, the monumental work attracted attention, but Savage had no funds to cast it, nor were there facilities to store it, so it was demolished. Afterwards, smaller versions were produced and bronzed. As a female Black artist, Savage had to compete for status among both male and White artists, and overall, her life and work embody hope.

Optimism and strength

This work of art was made against a background of resistance and has underlying meaning. Consider its mood and the feelings it stimulates, and try either saying out loud or writing down what you can see and think about this sculpture. Proud and creative, the figures are determined to make music. The monumentality of the original work was bold and powerful. Through its message and Savage's forbearance, it personifies hope; her faith and trust did not depend on permanence or security, but she looked towards an uncertain future, relying on her own indomitable optimism and determination.

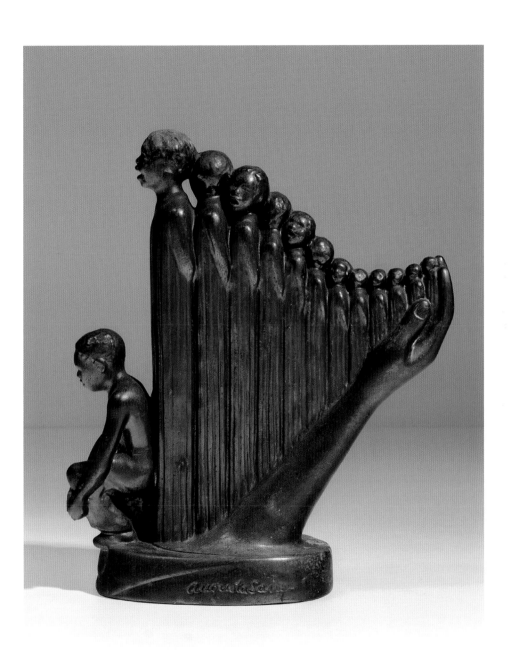

The Harp
1939 • bronze replica • 27.3 x 24.1 x 10.2 cm (10¾ x 9½ x 4 in.)
University of North Florida Gallery of Art, Jacksonville, Florida, USA

Finding Hope

Pere Borrell del Caso *'Everything that deceives may be said to enchant.'* Plato

Fooling the eye

Trampantojo is Spanish for 'sleight of hand' or 'trick'. Similar to the French *trompe-l'œil*, which means 'fool the eye', it refers to an artistic technique that creates optical illusions, making two-dimensional images look three-dimensional. The painter, illustrator and engraver Pere Borrell del Caso (1835–1910) was known for his *trampantojo* paintings. Born in the Catalan village of Puigcerdà, he learned cabinetmaking from his father. Later, he moved to Barcelona and studied art at the School of Industrial and Fine Arts (La Llotja), supporting himself by working part-time as a cabinetmaker. He was soon painting portraits and religious murals, exhibiting throughout Spain and at the Exposition Universelle in Paris in 1878. Although he was twice offered a professorship at La Llotja, he chose to teach at his own private art school, Sociedad de Bellas Artes, in Barcelona.

Sense of reality

In his characteristic Realist style, this is Borrell's most famous work. A dishevelled young boy seems to be trying to step out of the painting he is in. With one foot on the frame and his hands holding the sides, he appears both amazed at and worried about the world outside. Although it was never documented, some scholars have suggested that Borrell painted this work in reaction to the more extravagant Romantic style that was popular across much of Europe at the time. It is not clear whom the boy is escaping from. He wears no shoes, and a sense of reality is created by Borrell's powerful use of chiaroscuro. Parts of the boy's body that are already 'through' the frame are highlighted, while the rest remains dark.

Take a leap

Here, Borrell creates an optical illusion of a real window through which the boy steps into our world. The boy is aspirational; he could have remained safely in the frame, but he has chosen to break free and step into the unknown. Just as explorers did when sailing on the high seas in search of new lands in the sixteenth century, so this boy risks everything to discover a world beyond what he knows. He would not do it, of course, if he did not hope and believe that he would find something better on the other side. So, expectantly, he makes a dash for it. The painting shows that it is always possible to find ways of attaining what one wants or needs; sometimes all that is required is a leap into the unknown and the willingness to risk failure. The boy is apprehensive, but confident, and confidence reinforces hope.

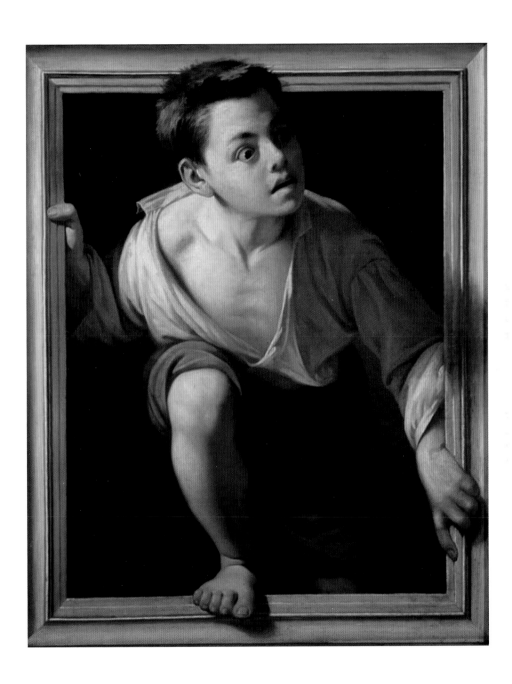

Escaping Criticism
1874 • oil on canvas • 75.7 x 61 cm (30 x 24 in.) • Banco de España, Madrid, Spain

Rembrandt van Rijn *'A painting is complete when it has the shadows of a god.'*

Soaring success

Rembrandt van Rijn (1606–1669) was born in Leiden, the Netherlands. He attended the University of Leiden, but left to undertake apprenticeships with two painters. After working in his home town for a while, in his own studio with another artist, he moved permanently to Amsterdam, where he began receiving important commissions from the Court of The Hague and many of the highest-ranking families and organizations. He married a rich woman, Saskia, and they moved to a big house, where he began spending extravagantly on collections of art and antiquities. Influenced by Italian art that he saw in prints, his success soared and he began using strong chiaroscuro and broader brushstrokes. Later in life, however, his style of art lost popularity and he declared bankruptcy to avoid imprisonment.

Spiritual light

Depicting the biblical story in which Jesus was born in a stable in Bethlehem and shepherds paid him homage there, this is one of seven paintings by Rembrandt illustrating Christ's life, all of them commissioned by the *stadtholder* (chief magistrate), the Prince of Orange, Frederik Henry. In this painting, Rembrandt used powerful chiaroscuro to create the sense that the baby, lying in a manger of straw, emits a spiritual light. The Holy Family and the worshipping shepherds surround him. Mary, Joseph and two of the shepherds are illuminated by the light emanating from the child. This light seems particularly dazzling in contrast with the darkness of the stable. Some animals and other reverential figures can just be made out in the gloom, all worshipping Jesus.

Memories

The power of Rembrandt's interpretation of this well-known story comes from his intense contrasts of light and dark. The illuminated baby represents hope, while the darkness of the stable signifies the lack of it that existed before his birth. Rembrandt created the composition to draw the viewer's eyes around, so that they notice several elements that might not have been initially apparent. Details such as the lantern and man's turban in the background are merely props to draw the viewer in to the drama. Everyone in the stable is clearly moved by the sight of the newborn child. The painting reminds the viewer of the excitement of a new birth, and also, for many, their own early years. Memory takes them back to those feelings of safety, providing support and hope despite any problems that might be faced now.

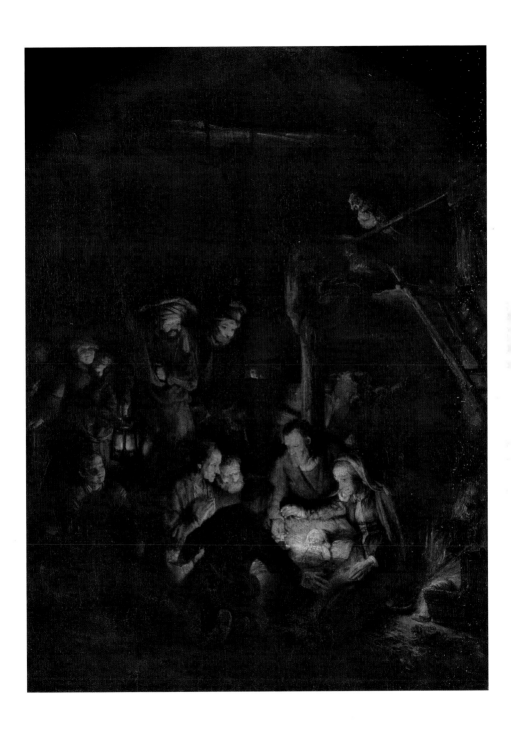

Adoration of the Shepherds
1646 • oil on canvas • 97 x 71.3 cm (38 x 28 in.) • Alte Pinakothek, Munich, Germany

Finding Hope

J.M.W. Turner *'To select, combine and concentrate all that which is beautiful in nature...is...the business of the landscape painter.'*

Turner's atmospherics

The English Romantic painter, printmaker and watercolourist Joseph Mallord William Turner (1775–1851) is known for his expressive landscape paintings. During his life he created more than 550 oil paintings, 2,000 watercolours and 30,000 works on paper, and was profoundly influential. He was born in London, and lived there for most of his life, although he travelled and sketched extensively around Europe. From the age of fourteen he studied at the Royal Academy of Arts in London; he exhibited his first work there at fifteen, and by twenty-seven he had been elected a Royal Academician. He also worked as an architectural draughtsman, and opened his own gallery. From 1807 until 1828 he lectured on perspective at the Royal Academy. After his father died in 1829, he suffered periods of depression, and his work became even more atmospheric.

Transparent and semi-opaque

Turner visited Switzerland several times, including in 1843 for an extended period. This view was commissioned by a Scottish art collector, and later owned by the writer and art critic John Ruskin (1819–1900), a great admirer of Turner. It depicts the sun rising over Lake Zug, and the light and atmospheric effects are created with successive applications of transparent and semi-opaque watercolours. As the sun rises between Mount Rossberg and Mount Mythen, it creates a shimmering reflection across the brilliant blue lake, which Turner created by leaving parts of the white paper unpainted, or scraping paint away. At the foot of the mountains is a small town, and in the foreground naked girls play in the lake, while elsewhere others are starting their day.

New beginnings

Ruskin described Turner as the artist who could most 'stirringly and truthfully measure the moods of nature', and here he demonstrates his uniqueness, with his creation of ephemeral atmospheric effects. However, he was among many artists who produced paintings that explore new beginnings. One of the most effective symbols for this notion is the sunrise. Having once said 'The sun is God,' Turner was fully aware of the power of the sun's effect in his paintings, and he and other artists also experimented with the juxtaposition of human life awakening and the brilliance of the natural world at dawn. These depictions of sunrises should be admired both for their face value and for their underlying significance, giving every viewer a surge of hope for the future.

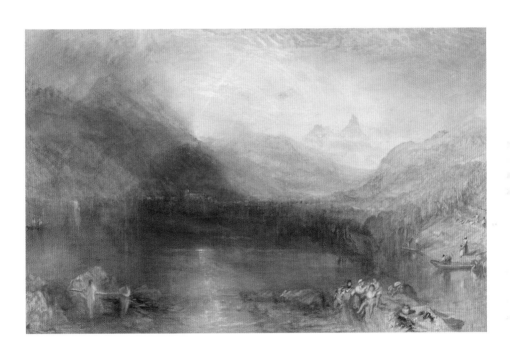

The Lake of Zug
1843 • watercolour over graphite • 29.8 x 46.6 cm (11¾ x 18⅜ in.)
The Metropolitan Museum of Art, New York, USA

Embracing Happiness

Van Gogh once wrote, 'Art is to console those who are broken by life', while the American textile artist and printmaker Anni Albers (1899–1994) declared that 'Art is something that makes you breathe with a different kind of happiness.'

An increasing amount of scientific evidence proves that art has the power to uplift. Art has an impact on brainwaves, the nervous system and dopamine levels; it can literally raise a person's mood. Additionally, cultural experiences, such as visiting galleries or museums, have been shown in various studies to be important for individual well-being. In *Art as Therapy*, Alain de Botton and John Armstrong explain how art can help us emotionally and alleviate a wide range of problems. This chapter explores all these aspects of art, and how it can instil happiness in us all, through artworks by artists including Judith Leyster, Henri Matisse, Niki de Saint Phalle, Akseli Gallen-Kallela, Franz Marc and Georges Seurat.

Cows, Yellow, Red, Green (detail) by Franz Marc; see page 177.

Embracing Happiness

Judith Leyster *'A painting is finished when the artist says it is finished.'* Rembrandt van Rijn

Dutch star

A contemporary of Rembrandt, Judith Leyster (1609–1660) was acclaimed during her lifetime, and was one of the first female painters to be admitted to Haarlem's Guild of Saint Luke. However, after she died much of her work was attributed to male artists. The youngest of eight, she was born in Haarlem, but details of her youth are uncertain. She was working as an artist by the age of nineteen, and she soon moved to Utrecht, where she adapted her style in line with the 'Utrecht Caravaggisti', a group of artists heavily influenced by Caravaggio. She specialized in genre scenes and expressive brushwork, and signed her paintings with a device of her initials in a star, which was a play on words, as *leister* means 'lode star' in Dutch.

Innocent fun

Two ruddy-cheeked children are laughing. The child in front holds a small black and white cat, which, although looking a little concerned, remains comfortably curled up. The boy holding the cat wears a smart light-brown coat with blue lacings, and blue trousers. His hair is unkempt and his fingers grubby, and his bright red hat has a jaunty curving black feather. The smaller boy wears grey; his hair is also messy and he has probably lost his hat. This type of relaxed genre painting with only a few animated figures was popular in the Netherlands in the 1620s, and Leyster was an expert at capturing the lively personalities with her loose, confident brushwork, natural palette and light application of paint.

Think like a child

When an adult feels happiness, they often subconsciously compare the feeling to past experiences, or measure it against whatever else is going on at the time. Their joy is rarely as free and innocent as a child's. This painting evokes the children's carefree sense of fun and happiness. They appear to be living in the moment, enjoying themselves, without any feelings of guilt or underlying worries about other matters. The casual composition and quick, dynamic brushstrokes in their hair suggests the fast-moving nature of everyday child's play; Leyster reminds us of what it is like to be a child. As Andy Warhol said, 'You need to let the little things that would ordinarily bore you, suddenly thrill you.'

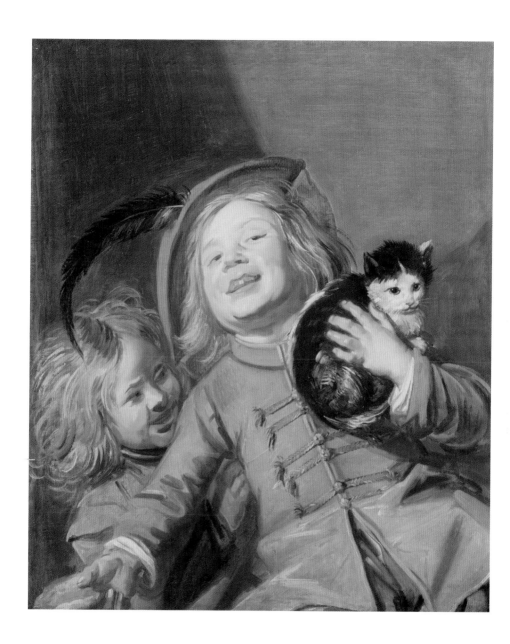

Laughing Children with a Cat
1629 • oil on canvas • 61 x 52 cm (24 x 20½ in.) • Private Collection

Embracing Happiness

Henri Matisse *'He who loves, flies, runs, and rejoices; he is free and nothing holds him back.'*

Matisse's challenges

Although he trained as a lawyer, Henri Matisse (1869–1954) discovered the therapeutic benefits of painting when he was twenty-one and convalescing from appendicitis. In 1905, with André Derain (1880–1954), he initiated Fauvism, a colourful, emotional art movement. Later, at the age of eighty-two, when he had undergone two operations for intestinal cancer, he proved the healing power of art on himself. Mainly bedridden, he lost the physical strength to paint, but, rather than succumbing to depression, he created art. Using scissors, he cut shapes from sheets of paper brightly painted with gouache. When he was satisfied with his arrangements, he glued them on to large supports of paper or canvas. In this way he clearly proved that art heals.

Arcadian landscape

In the image shown here, Matisse depicted the manifestation of happiness in a painting that is now regarded as one of the forerunners of modernism. It was exhibited in Paris in March 1906 and possibly inspired Picasso to paint his ground-breaking *Les Demoiselles d'Avignon* (1907). In a woodland, naked figures recline, talk, kiss, dance and play music. The colours and distortion make it almost an abstraction. The place is Arcadia, a mythical location described in ancient texts and poetry as an idyllic place where people live in bliss, close to nature and uncorrupted. One of Matisse's last statements expressed his beliefs about the effects of painting: 'Colours win you over.… A certain blue enters your soul. A certain red has an effect on your blood pressure.'

Good health

As Matisse seems to have known, art can make you happy and improve your physical health. He once wrote that he sought to create art that would be 'a soothing, calming influence on the mind, rather like a good armchair'. His innovative use of colour, line and form, and his original interpretations of the world around him, may first have helped to improve his own health and moderate his concerns about post-war France, but Matisse's art is uplifting and heartening for all. This image exudes joy, its central figures haloed in brilliant colour while all around them others are shown enjoying themselves. The difference the arts make to our well-being has found its way into the image, in the circle of joyous dancers and the figures playing music.

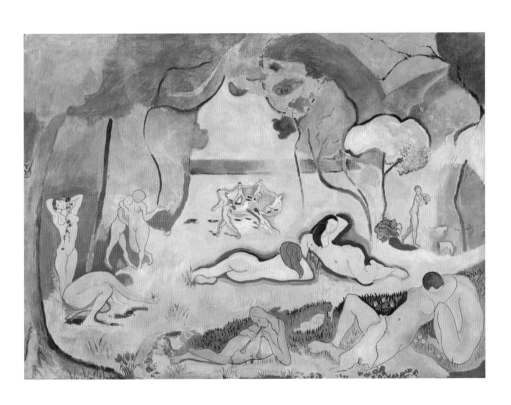

The Joy of Life
1905 · oil on canvas · 176.5 x 240.7 cm (69½ x 94¾ in.) · Barnes Foundation, Philadelphia, USA

Embracing Happiness

Niki de Saint Phalle *'Painting calmed the chaos that shook my soul.'*

Saint Phalle's determination

Parisian-born Niki de Saint Phalle (1930–2002) produced huge female figures that often contain underlying, disturbing elements. From an aristocratic Catholic family, her French father lost his wealth during the Great Depression and the family moved to her mother's home in New York City. At eighteen she eloped with a childhood friend and they moved back to Paris, then travelled around Europe. After being diagnosed with a 'nervous breakdown' and hospitalized in a psychiatric facility, she began painting, moving to Majorca, where she became inspired by the work of Antoni Gaudí (1852–1926). With her second husband, the artist Jean Tinguely (1925–1991), she became involved in the Nouveau Réalisme movement. Her most famous works, the *Nanas*, were created in the 1960s in response to the denigration of women by men.

Voluptuous figure

Part of Saint Phalle's *Nana* series, this woman stands confidently. Her curves are exaggerated, her head diminished. She represents all women. Venus was the Roman goddess of love, beauty and fertility, but, unlike stereotypical depictions of her from previous artistic traditions, this large-limbed Black figure 'dances' unselfconsciously in her vibrantly decorated bathing costume while playing with a beach ball. By portraying the goddess of love and beauty as strong, active and Black, rather than mild, passive and White, Saint Phalle particularly celebrates Black women. She also made a series of White and other coloured *Nanas* to convey that all women are goddesses.

Bringing joy

When she was twenty-five, Saint Phalle visited Gaudí's Park Güell in Barcelona, and she later recalled that on seeing it, her life changed: 'I told myself that one day, I too would build a garden of happiness. I saw the mothers with their children, and felt an air of freedom; the people seemed to have left the worries of their daily lives far behind. Adults and children were there in an atmosphere of dreams, and of joy.' Art for Saint Phalle was therapy. Making art helped her to banish her own distress, keeping her mind busy and enabling her to convey happiness to others. She said, 'I am giving something back to society. I want to bring people joy.' Her *Nanas* are expressions of sheer enjoyment. The bright colours, patterns, curves and suggestion of dance all create a sense of happiness, as the exuberant figure seems to invite others to join her.

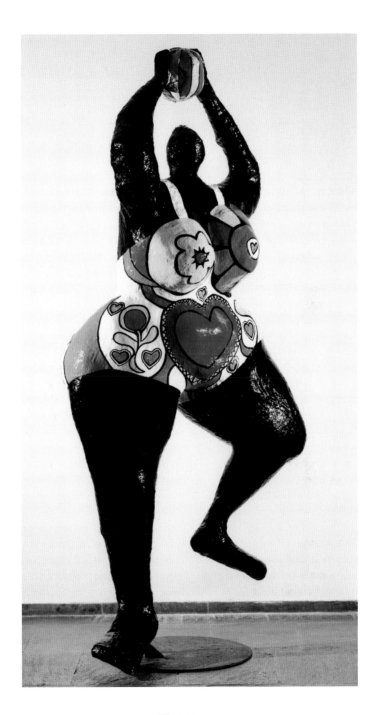

Black Venus
1965–67 • painted polyester • 279.4 x 131.1 x 78.3 cm (110 x 51⅝ x 30¾ in.)
Whitney Museum of American Art, New York, USA

Embracing Happiness

Akseli Gallen-Kallela *'Silvery stripes at the surface of the serene water are the wavelets announcing the passion to come.'*

The Kalevala

Famous for his paintings of the Finnish national epic *The Kalevala* and of Finland's countryside and people, Akseli Gallen-Kallela (1865–1931) was influenced by Realism and Symbolism. Published in 1835, *The Kalevala* (Land of Heroes) was a compilation of Finnish folk songs and poems. Gallen-Kallela loved both the work and Finland itself, and although he travelled and painted extensively, he always preferred his own land. From 1878 he took drawing classes in Helsinki, and from 1882 to 1889 he was tutored in Paris, both by a Finnish artist and at the Académie Julian and Atelier Cormon. Back in Finland, in 1888, Gallen-Kallela painted a triptych based on a scene from *The Kalevala* called *The Aino Myth*. It was so well received that the Finnish state commissioned him to paint a second version. Other *Kalevala* scenes followed with corresponding popularity.

Väinämöinen's wake

One of four paintings that Gallen-Kallela produced in 1905 of the remote Lake Keitele in central Finland, this image reflects the mood of Finnish nationalism that was growing at the time. From 1809 until 1917 Finland was an autonomous part of the Russian Empire, and by the late nineteenth century the Finnish people wanted to break away. Drawing on ideas from *The Kalevala*, Gallen-Kallela expresses this desire. He described the shimmering zigzag pattern on the surface of the lake as 'Väinämöinen's wake', Väinämöinen being the principal character of *The Kalevala*. The zigzags are actually a natural occurrence, caused by the wind and the lake's currents.

Calmness and joy

Combining the idea of serenity with nature's powerful forces, and Finnish mythology with national politics of the time, Gallen-Kallela creates an atmospheric scene that can be viewed at face value or through the romance of ancient narratives. Either way, this tranquil-looking Finnish lake with its tree-covered island, the image completely empty of people, arouses notions of freedom and the supernatural. The image is strangely familiar, even nostalgic, though it is set in an isolated location in Finland, where many have never been. The combination of independence, intimacy and reminiscence can stimulate pleasure, but above all, this particular scene has a sense of utter calm. It might be used by the viewer as an image for meditation.

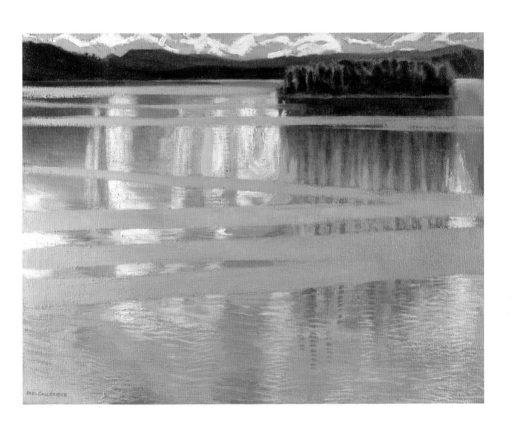

Lake Keitele
1905 • oil on canvas • 53 x 66 cm (20⅞ x 26 in.) • The National Gallery, London, UK

Embracing Happiness

Franz Marc '*Art today is moving in directions of which our forebears had no inkling...artistic excitement can be felt all over Europe.*'

The fate of humanity

Although his career was cut short by his early death, Franz Marc (1880–1916) had a great impact on various Expressionist movements that evolved after World War I. Born in Munich, he studied theology and philosophy before attending Munich's art academy, and then visited Paris, where he became particularly influenced by Van Gogh and the Post-Impressionists. In 1909 he moved to the countryside, and he became famous for depicting animals in brightly coloured paintings that contain implications about the natural world and the fate of humanity. With Kandinsky, Marc founded the Expressionist group Der Blaue Reiter, which emphasized the use of abstracted forms and bold colours to communicate concerns about the state of the modern world.

Avoiding sentimentality

While he often painted animals, Marc avoided sentimentality. He believed that creatures possess virtues that humans have lost. In 1915 he wrote: 'People with their lack of piety, especially men, never touched my true feelings, but animals with their virginal sense of life awakened all that was good in me.' This is a joyous image. Like Van Gogh, Marc used colour to represent emotion, and colour symbolism is an essential aspect of the painting. Here, a red calf and a green bull are behind the yellow cow. Yellow for

Marc represented femininity and joy, and he painted this work to express his love for his second wife, Maria Franck, also an artist. The cow itself represents the safety, security and happiness he felt in their union.

Gentle and sensual

Leaping happily, the yellow cow dominates the foreground of a colourful composition that exudes a mood of idyllic contentment. Marc believed strongly in the potential of colour to affect mood, and by late 1910, just before he painted this work, he had developed his own theory of colour symbolism, including: 'Yellow is the female principle, gentle, happy and sensual[,] and red the colour of primal nature.' In this painting, which is extremely similar to his famous work *The Yellow Cow* (1911; Solomon R. Guggenheim Museum, New York), the abundance of golden yellow was intended to emit feelings of happiness, in the same way that Van Gogh used it, reminding the viewer of the uplifting effect of the sun's golden rays.

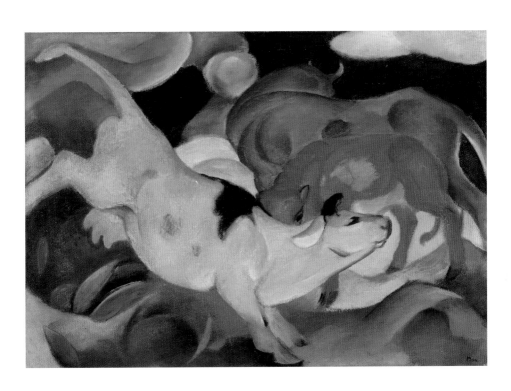

Cows, Yellow, Red, Green
1911 • oil on canvas • 62 x 87.5 cm (24½ x 34½ in.)
Städtische Galerie im Lenbachhaus, Munich, Germany

Georges Seurat *'They [those who praise his work] see poetry in what I have done.'*

Seurat's divisionism

One of the most important Post-Impressionists and the founder of Neo-Impressionism, Georges Seurat (1859–1891) built on the Impressionists' use of colour, but abandoned the apparent spontaneity of their brushwork and developed a more structured, scientific approach with colour. He became famous for his technique of tiny marks of pure colour, known as Divisionism or Pointillism. A Parisian, Seurat studied art at the Ecole des Beaux-Arts, at the Louvre and with the highly respected Pierre Puvis de Chavannes (1824–1898). Initially, he produced tonal drawings in Conté crayon, and then became fascinated by scientific theories on colour, especially the juxtaposition of complementary colours to create brighter optical effects. Although he died aged just thirty-one, his innovations were highly influential.

Thousands of dots

This vast painting created a sensation when it was shown at the eighth and final Impressionist exhibition in Paris in 1886. Nothing like it had been seen before. Representing Parisians enjoying a relaxing afternoon on a small island on the River Seine, the work is monumental and innovative. Using a methodical process, Seurat built up the image using small dots and dashes of pure colour, basing his approach on scientific theories that when colours are placed on the canvas adjacent to each other, without being mixed on a palette beforehand, the resulting colours appear more luminous. The composition is deliberately unrealistic. After making many preparatory studies in which he experimented with various groupings, Seurat created simplified and stylized figures from different social classes, with expressionless, anonymous faces.

Lines and angles

At the exhibition where Seurat showed this painting, he met the scientist Charles Henry (1859–1926), who in 1885 had published a book of his theories about the psychological and physiological effects that lines and colours have on viewers. He proposed that the direction, number and angle of lines all affect the viewer's perception and emotions. He also proposed that, depending on their angles, lines can be rhythmic or dynamic, and can arouse energetic and cheerful feelings. These concepts confirmed Seurat's own ideas. He believed that, for example, horizontal lines denote calmness, while upward- and downward-sloping lines communicate happiness and sadness respectively. Bearing this in mind, note the emphasis on upward lines in this composition – Seurat intended this painting to inspire happiness.

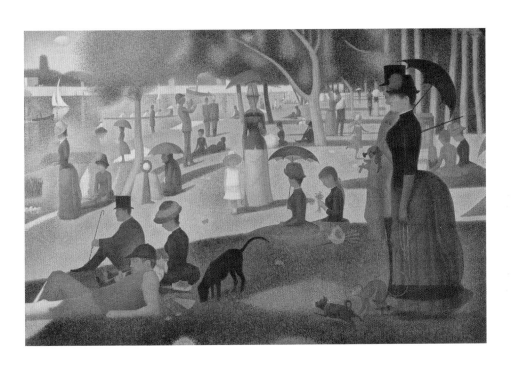

A Sunday Afternoon on the Island of La Grande Jatte
1884–86 • oil on canvas • 207.5 x 308 cm (81¾ x 121¼ in.)
Art Institute of Chicago, Illinois, USA

Quotations

Page 14 Quoted in *Notes d'un Peintre* (Notes of a Painter), Henri Matisse, 1908, p. 413 (republished by Centre Georges Pompidou Service Commercial, 12 October 2011) **page 16** Quoted in John Gruen, *The Artist Observed: 28 Interviews with Contemporary Artists* (Chicago: Chicago Review Press, 1991), p. 3 **page 18** Quoted in *Orazio and Artemisia Gentileschi* (New York: The Metropolitan Museum of Art, 2001) **page 20** George Grosz, *The Autobiography of George Grosz: A Small Yes and a Big No* [1946], trans. Arnold Pomerans (London: Allison & Busby, 1982) **page 22** Nina Azzarello, 'Interview with Pipilotti Rist as Major Exhibit Opens at the Louisiana Museum of Modern Art', 17 March 2019, www.designboom.com/art/pipilotti-rist-interview-louisiana-museum-denmark-03-17-2019 **page 24** Revelation 6:17, King James Bible **page 28** Diary entry 1 April 1920, *The Diary and Letters of Kaethe Kollwitz* (Evanston, IL: Northwestern University Press, 1988) **page 30** Rebecca Jagoe, 'Colonialism and Cultural Hybridity: An Interview with Yinka Shonibare, MBE', 13 January 2017, https://theculturetrip.com/africa/nigeria/articles/colonialism-and-cultural-hybridity-an-interview-with-yinka-shonibare-mbe **page 32** Louise Bourgeois, *Destruction of the Father/Reconstruction of the Father: Writings and Interviews, 1923–1997* (Cambridge, MA: MIT Press, 1998) **page 34** Quoted in Sacha Llewellyn, *Winifred Knights (1899–1947)*, exhibition catalogue (London: Dulwich Picture Gallery, 2016) **page 36** Quoted in Annabelle Gorgen and Hubertus Gassner, *Helene Schjerfbeck: 1862–1946* (Munich: Hirmer Verlag, 2007), p. 35 **page 38** Letter from Goya to his friend Don Martín Zapater, dated February 1784, one of 132 surviving letters written by Goya to Zapater between 1775 and 1801; *Goya, A Life in Letters* (London: Pimlico, 2004) **page 42** Monet in a letter to Frédéric Bazille, 1864 **page 44** Diary illustration from 1953, Hayden Herrera, *Frida: A Biography of Frida Kahlo* (London: Bloomsbury, 1983), p. 415 **page 46** Quoted in Selden Rodman, *Conversations with Artists* (New York: Devin-Adair Co., 1957) **page 48** Quoted in Frank Whitford, *Klimt* (London: Thames & Hudson, 1990), p. 18 **page 50** Yayoi Kusama, *Infinity Net: The Autobiography of Yayoi Kusama* (London: Tate Publishing, 2013) **page 52** Letter of 1886 from Claudel to Auguste Rodin, quoted on a plaque at 19 Quai de Bourbon, Paris **page 56** Quoted in Dennis Abrams, *Georgia O'Keeffe* (New York: Infobase Publishing, 2009) **page 58** Isabelle Graw interview, *Wolkenkratzer Art Journal*, 1986 **page 60** *Andrew Wyeth: Autobiography* (New York: Little, Brown, 1999) **page 62** Quoted in Arne Glimcher, *Agnes Martin: Paintings, Writings, Remembrances* (London: Phaidon, 2012) **page 64** Diary entry, 3 June 1902, #411 in *The Diaries of Paul Klee, 1898–1918* (Berkeley: University of California Press, 1968) **page 66** Georges Duthuit, 'Où allez-vous Miró?' (Where do you go, Miró?), *Cahiers d'Art*, xi/8–10, 1936 **page 70** Quoted in *The Private Journals of Edvard Munch: We Are Flames Which Pour Out of the Earth* (Madison: University of Wisconsin Press, 2005) **page 72** Quoted in Helmut Börsch-Supan, *Caspar David Friedrich* (New York: George Braziller, 1974), pp. 7–8 **page 74** Quoted in J. L. Jules David, *Le Peintre Louis David 1748–1825* (Paris: Victor-Havard, 1880) **page 76** Quoted

in Dan Cameron, *Dancing at the Louvre: Faith Ringgold's French Collection and Other Story Quilts* (Berkeley: University of California Press, 1998) **page 78** Q+A with Alexander in *Art in America*, 3 August 2012, www.artnews.com/art-in-america/interviews/jane-alexander-cam-houston-56282 **page 80** Kiefer, 2011, quoted in *Wall Street International magazine*, 6 August 2012 **page 84** Rothko, 1949. Daugavpils Mark Rothko Art Centre **page 86** Quoted in *Michelangelo: Poems and Letters: Selections* (London: Penguin, 2007) **page 88** Quoted in *LIFE*, LVII/11 (11 September 1964), p. 9 **page 90** Psalms 147:3, The King James Bible **page 92** American Humanist Association, www. americanhumanist.org/what-is-humanism/definition-of-humanism **page 94** Quoted in Roberto Longhi, *Caravaggio* (Frankfurt: Edition Leipzig, 1968) **page 98** Quoted in Miles Menander Dawson, *The Ethics of Confucius* (New York: Cosimo, 2005) **page 100** Quoted in *Barbara Hepworth: A Pictorial Biography* (London: Tate Publishing, 1970) **page 102** Excerpt of letter from Vincent van Gogh to Theo van Gogh, The Hague, 8 or 9 January 1882 **page 104** Quoted in Karl R. Popper, Introduction to *Conjectures and Refutations: The Growth of Scientific Knowledge* (New York: Basic Books, 1962) **page 106** Quoted in Laban Carrick Hill, *Harlem Stomp!: A Cultural History of the Harlem Renaissance* (New York: Little, Brown, 2011) **page 108** Marcel Proust, *À la Recherche du Temps Perdu* (Paris: Grasset and Gallimard, 1913–27), published in English as *Remembrance of Things Past*, vol. VII: *The Past Recaptured* (1927), ch. 3: 'An Afternoon Party at the House of the Princesse de Guermantes' (London: Chatto & Windus, 1931) **page 112** Quoted by Toledo Museum of Art, Ohio: http://emuseum.toledomuseum.org/objects/54999 **page 114** Letter from Sargent to Claude Monet from 1 rue Tronchet, Paris **page 116** www.phillips.com/detail/kara-walker/ UK010820/42 **page 118** Quoted by Samella Lewis in *IRAAA Journal* (then called *Black Art*), I (Autumn 1976) **page 120** Quoted in Sikh Heritage, www.sikh-heritage.co.uk/arts/amritashergil/ amritashergill.html **page 122** Quoted in Thoughtco., www.thoughtco.com/mary-cassatt-quotes-3530144 **page 126** From an interview in 1910, cited in Cornelia Stabenow, *Henri Rousseau 1844–1910* (Cologne: Taschen, 2001), p. 25 **page 128** Quoted in Kelly Richman-Abdou, 'Rediscovering Joaquín Sorolla: The Spanish Impressionist Known as a "Master of Light"', 14 April 2019, www.mymodernmet.com/joaquin-sorolla-spanish-impressionism **page 130** Inscription on the frame of Van Eyck's *Man in the Red Turban*, 1433 **page 132** Quoted in Christopher Makos, *Warhol Memoir* (Milan: Edizioni Charta, 2009) **page 134** Quoted by Tate Modern, www.tate.org. uk/art/artworks/rego-the-firemen-of-alijo-t07778 **page 136** Quoted by Tate Modern, www.tate. org.uk/art/artists/lubaina-himid-2356/lubaina-himid-painter-and-cultural-activist **page 140** Quoted in *Degas' Ballet Dancers* (New York: Universe, 1992) **page 142** Quoted in *University of Illinois Extension*, Summer 2017 **page 144** From Piet Mondrian, 'The Grand Boulevards', *De Groene Amsterdammer*, 27 March 1920, pp. 4–5 **page 146** Quoted in James A. Michener, *The Hokusai Sketchbooks: Selections from the Manga* (North Clarendon, VT: Charles E. Tuttle, 1965) **page 148** Quoted in Stephen F. Eisenman, ed., *Nineteenth Century Art: A Critical History*, 3rd edn (London: Thames & Hudson, 2007), pp. 18–54 **page 150** Marc Chagall, *Chagall by Chagall* (New York: Harry N. Abrams, 1979) **page 154** Attributed to Rodin in Herbert Read, *Modern Sculpture:*

A Concise History (London: Thames & Hudson, 1964), as cited in Karl H. Pfenninger and Valerie R. Shubik, *The Origins of Creativity* (Oxford: Oxford University Press, 2001), p. 50 **page 156** Wassily Kandinsky, *Concerning the Spiritual in Art* [1910], trans. Michael T. H. Sadler (Mineola, NY: Dover Publications, 2011) **page 158** Quoted by Smithsonian American Art Museum, www.americanart. si.edu/artist/augusta-savage-4269 **page 160** Plato, *Republic*, Book III, section 413c **page 162** Attributed to Rembrandt in early biographies, as quoted in Alison MacQueen, *The Rise of the Cult of Rembrandt: Reinventing an Old Master in Nineteenth-century France* (Amsterdam: Amsterdam University Press, 2014) **page 164** Turner, *c.* 1810, quoted in Dennis Hugh Halloran, *The Classical Landscape Paintings of J.M.W. Turner* (Madison: University of Wisconsin Press, 1970), p. 75 **page 168** Attributed to Rembrandt in early biographies, as quoted in MacQueen, *The Rise of the Cult of Rembrandt* **page 170** Quoted in Jack Flam, ed., *Matisse on Art* (Berkeley: University of California Press, 1995) **page 172** Quoted by Guggenheim Bilbao, http://nikidesaintphalle.guggenheim-bilbao.eus/en/painting-violence **page 174** Quoted by National Gallery, London, www. nationalgallery.org.uk/paintings/akseli-gallen-kallela-lake-keitele **page 176** Marc's Manifesto for 'Der Blaue Reiter' group, 1912, as quoted in Richard Friedenthal, *Letters of the Great Artists: From Blake to Pollock* (London: Thames & Hudson, 1963), p. 207 **page 178** Quoted in John Rewald, *Post-Impressionism, from Van Gogh to Gauguin* (New York: Museum of Modern Art, 1956), p. 86.

Picture credits

2 Wikimedia Commons 7 Photo: Nasjonalmuseet/Høstland, Børre 8 The Metropolitan Museum of Art, New York/Marquand Fund, 1959 10 National Gallery of Art, Washington/Gift of Victoria Nebeker Coberly, in memory of her son John W. Mudd, and Walter H. and Leonore Annenberg 12 © Christopher Wood Gallery, London, UK/Bridgeman Images 15 Mondadori Portfolio/Archivio Antonio Quattrone/Antonio Quattrone/Bridgeman Images 17 © The Estate of Francis Bacon. All rights reserved, DACS/Artimage 2022. Photo: Prudence Cuming Associates Ltd 19 incamerastock/Alamy Stock Photo 21 © Estate of George Grosz, Princeton, N.J./DACS 2022. Photo © Peter Willi/Bridgeman Images 23 © Pipilotti Rist. Courtesy the artist, Hauser & Wirth and Luhring Augustine 25 © Christopher Wood Gallery, London, UK/Bridgeman Images 26 Wikimedia Commons 29 Album/Alamy Stock Photo 31 © Yinka Shonibare CBE. All rights reserved, DACS/Artimage 2022. Image courtesy Stephen Friedman Gallery. Photo: Stephen White & Co. 33 © The Easton Foundation/VAGA at ARS, NY and DACS, London 2022. Photo © Tate 35 Photo © Tate 37 Photo: Finnish National Gallery 39 Wikimedia Commons 40 © Yayoi Kusama. Photo © Tate 43 National Gallery of Art, Washington/Gift of Victoria Nebeker Coberly, in memory of her son John W. Mudd, and Walter H. and Leonore Annenberg 45 © Banco de México Diego Rivera Frida Kahlo Museums Trust, Mexico, D.F./DACS 2022. Bridgeman Images 47 © The Pollock-Krasner Foundation ARS, NY and DACS, London 2022/Bridgeman Images 49 Artothek/Bridgeman Images 51 © Yayoi Kusama. Photo © Tate 53 Wikimedia Commons/Pierre André Leclercq 54 Bridgeman Images 57 © Georgie O'Keeffe Museum/DACS 2022. Museum purchase funded by the Agnes Cullen Arnold Endowment Fund/Bridgeman Images 59 © The Estate of Jean-Michel Basquiat/ADAGP, Paris and DACS, London 2022. Photo © Christie's Images/Bridgeman Images 61 © Andrew Wyeth/ARS, NY and DACS, London 2022. Digital image, Museum of Modern Art, New York/Scala, Florence 63 © Agnes Martin Foundation, New York/DACS 2022. The Doris and Donald Fisher Collection at the San Francisco Museum of Modern Art. Photo: Katherine Du Tiel 65 Bridgeman Images 67 © Successió Miró/ADAGP, Paris and DACS, London 2022. Bridgeman Images 68 Bridgeman Images 71 Photo: Nasjonalmuseet/Høstland, Børre 73 Bridgeman Images 75 Wikimedia Commons 77 © Faith Ringgold/ARS, NY and DACS, London, courtesy ACA Galleries, New York 2022. Image copyright The Metropolitan Museum of Art/Art Resource/Scala, Florence 79 © Jane Alexander/DALRO/DACS 2022. Photo © Tate 81 © Anselm Kiefer. Photo: Atelier Anselm Kiefer 82 Photo © Leonard de Selva/Bridgeman Images 85 © 1998 Kate Rothko Prizel & Christopher Rothko ARS, NY and DACS, London. Photo © Christie's Images/Bridgeman Images 87 Wikimedia Commons 89 © Succession Picasso/DACS, London 2022. Photo © Tate 91 Harvard Art Museums/Fogg Museum, The Kate, Maurice R. and Melvin R. Seiden Special Purchase Fund in honour of Marjorie B. Cohn 93 Photo © Raffaello Bencini/Bridgeman Images 95 Photo © Leonard de Selva/Bridgeman Images 96 Wikimedia Commons

99 Wikimedia Commons/National Library of China **101** Barbara Hepworth © Bowness. Photo © The Hepworth Wakefield/Bridgeman Images **103** Wikimedia Commons **105** The Metropolitan Museum of Art, New York/Harris Brisbane Dick Fund, 1943 **107** © Heirs of Aaron Douglas/ VAGA at ARS, NY and DACS, London 2022. National Gallery of Art, Washington **109** Widener Collection/National Gallery of Art, Washington **110** Photo: Robert Glowacki. Artwork © Kara Walker, courtesy of Sikkema Jenkins & Co., New York **113** © Philadelphia Museum of Art/ Purchased with the W. P. Wilstach Fund, 1899 **115** Wikimedia Commons **116** Installation view: *Kara Walker: Go to Hell or Atlanta, Whichever Comes First*, Victoria Miro, London, UK, 2015. Photo: Robert Glowacki **119** © Catlett Mora Family Trust/VAGA at ARS, NY and DACS, London 2022. Photo © Philadelphia Museum of Art/Purchased with the Alice Newton Osborn Fund, 1999/ Bridgeman Images **121** GL Archive/Alamy Stock Photo **123** National Gallery of Art, Washington/ Chester Dale Collection **124** Wikimedia Commons **127** Wikimedia Commons **129** Wikimedia Commons **131** Wikimedia Commons **133** © 2022 The Andy Warhol Foundation for the Visual Arts, Inc./Licensed by DACS, London. Photo © Albright-Knox Gallery/Art Resource, NY/Scala, Florence **135** © Paula Rego. Courtesy Victoria Miro, London. Photo: Bridgeman Images **137** © Lubaina Himid. Image courtesy the artist, Hollybush Gardens, London, and National Museums, Liverpool. © Spike Island, Bristol. Photo: Stuart Whipps **138** Wikimedia Commons/The Whitehouse Historical Association **141** The Metropolitan Museum of Art, New York/Bequest of Mrs Harry Payne Bingham, 1986 **143** Wikimedia Commons/The Whitehouse Historical Association **145** © 2022 Digital image, Museum of Modern Art, New York/Scala, Florence **147** The Metropolitan Museum of Art, New York/H. O. Havemeyer Collection. Bequest of Mrs H. O. Havemeyer, 1929 **149** Wikimedia Commons **151** © ADAGP, Paris and DACS, London 2022. © 2022 Photo Scala, Florence **152** Städtische Galerie im Lenbachhaus und Kunstbau, Munich, Gabriele Münter Stiftung 1957 **155** National Gallery of Art, Washington/Gift of Mrs John W. Simpson **157** Städtische Galerie im Lenbachhaus und Kunstbau, Munich, Gabriele Münter Stiftung 1957 **159** Digital commons/University of North Florida Gallery of Art, Jacksonville, Florida **161** ART Collection/Alamy Stock Photo **163** Bridgeman Images **165** The Metropolitan Museum of Art, New York/Marquand Fund, 1959 **166** Städtische Galerie im Lenbachhaus und Kunstbau, Munich **169** Bridgeman Images **171** © 2022 Succession H. Matisse/DACS 2022. Photo © The Barnes Foundation/Bridgeman Images **173** © Niki de Saint Phalle Charitable Art Foundation/ ADAGP, Paris and DACS, London 2022. © 2022 Digital image Whitney Museum of American Art/ Licensed by Scala **175** Bridgeman Images **177** Städtische Galerie im Lenbachhaus und Kunstbau, Munich **179** Art Institute of Chicago, Illinois/Helen Birch Bartlett Memorial Collection.

Index

Frontispiece: Vincent van Gogh, *The Starry Night*; see page 103

First published in the United Kingdom in 2022 by
Thames & Hudson Ltd, 181A High Holborn, London WC1V 7QX

First published in the United States of America in 2022 by
Thames & Hudson Inc., 500 Fifth Avenue, New York, New York 10110

How Art Can Change Your Life © 2022 Mark Fletcher
Text by Susie Hodge

Susie Hodge has asserted her right under Copyright, Designs,
and Patents Act 1988 to be identified as the Author of this work.

Designed by John Round Design

British Library Cataloguing-in-Publication Data
A catalogue record for this book is available from the British Library

Library of Congress Control Number 2021943607

ISBN 978-0-500-02493-5

Printed and bound in Italy by L.E.G.O. S.p.A. - Lavis (TN)

Be the first to know about our new releases,
exclusive content and author events by visiting
thamesandhudson.com
thamesandhudsonusa.com
thamesandhudson.com.au